Professional Techniques for

DIGITAL WEDDING PHOTOGRAPHY

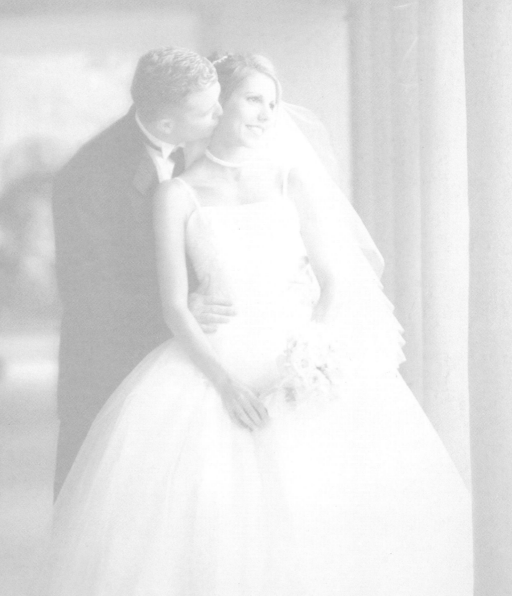

Jeff Hawkins *and* Kathleen Hawkins

AMHERST MEDIA, INC. ■ BUFFALO, NY

► DEDICATION

This book is dedicated to Melissa Anderson, our production assistant and associate photographer. Melissa began working with us in the midst of digital chaos—not knowing even where the Exit key on the keyboard was located! Now, she is a fabulous production assistant and associate photographer. Thank you Melissa, for giving us a part of our lives back! We appreciate you and all that you do. We would not have had the time to complete this project, if it wasn't for you!

Published by:
Amherst Media, Inc.
P.O. Box 586
Buffalo, N.Y. 14226
Fax: 716-874-4508
www.AmherstMedia.com

Publisher: Craig Alesse
Senior Editor/Production Manager: Michelle Perkins
Assistant Editor: Barbara A. Lynch-Johnt

ISBN: 1-58428-073-5
Library of Congress Control Number: 2001 133136

Printed in Korea.
10 9 8 7 6 5 4 3 2 1

TABLE OF CONTENTS

▶ ACKNOWLEDGMENTS

• Thanks to all of the contributors to the "Ask the Experts" chapter located at the back of this book. You have been mentors and provided us with a wealth of knowledge and guidance in this transition. These contributors are: Bill Hurter, Curt Littlecott, Stewart and Susan Powers, Barbara and Patrick Rice, Curtis Tackett and Eddie Tapp.

• To our sponsors: Art Leather, Quantum Instruments, Hood Man, GJC Software (EZ-Viewer®) and More Photos. Thank you for all you do!

• To all of our clients in this book. It has been a privilege and an honor to capture your special days.

• To Missie Lopez, Art Director for *The Perfect Wedding Guide*, for always helping us when we need anything at all, and for making us look so good in the community.

• To Betty, Jerry and Mom for providing a safe haven where we could hibernate periodically—away from cellular phones, e-mails and all the other daily stresses of life—to concentrate on completing this project.

▶ ABOUT THE AUTHORS

Jeff Hawkins has been a professional photographer for nearly twenty years. Beginning his print competition career just over three short years ago, he is proud to have earned merits on fourteen out of seventeen entries! He took the leap into the millennium by becoming the first photographer in central Florida to make the digital transition with his upscale weddings.

Kathleen Hawkins served as a Business Administration University Professor, and has proudly helped to develop the wedding industry in their community, serving as the President of the Wedding Professionals of Central Florida (WPCF).

As a team, they are the authors of *Professional Marketing & Selling Techniques for Wedding Photographers*, published by Amherst Media. They

PHOTO BY ED PIERCE

take pride in their impact in the community, and having been nominated "Small Business of the Year" by the Seminole Chamber of Commerce.

INTRODUCTION

TELEPHONES, TELEVISION, MICROWAVES, MICROCHIPS, calculators, CD players, cellular phones, palm pilots, debit cards, and DVDs—as technology changes, so do we. Can you imagine life without the convenience of phones, cars, or computers? Unthinkable, isn't it?

Visualize where your company will be without making the digital transition. Where will you stand in the marketplace?

Well, let's move forward to 2010. Now, visualize where your company will be without making the digital transition. Where will you stand in the marketplace? How will your clients view you in relation to your competitors? Will you even be able to compete? Eventually, clients will notice the photographers who have not made the transition—they will see imperfections in their images, such as oily skin, exit signs, and threads or bras showing in the bride's formals. The failure to eliminate these flaws will make these photographers' work inherently inferior and less marketable.

This book will take you on a digital journey. Together, we will analyze the philosophy required to make this change, explore the benefits of constructing the digital transition and unravel the steps and systems necessary to implement this new technology and build an effective digital workflow.

PHILOSOPHY

S UCCESSFUL WEDDING PHOTOGRAPHY IS ABOUT MORE than just new equipment and creativity. It is about analyzing your competition, establishing your market, and being viewed as an authoritative leader within your industry. This can not be accomplished by remaining in the

Overcoming the fear of change, accepting the future, and comparing the payoffs to the cost can build the resolution needed to begin.

dark ages. But how does one move forward? Overcoming the fear of change, accepting the future, and comparing the payoffs to the cost can build the resolution needed to begin. Let us examine the fear factors that may be involved.

1. Are you afraid of change?
2. Are you stuck in your comfort zone?
3. Does technology intimidate you? Are you technophobic?
4. Are you afraid of losing the acquired digital images? Do you view film as a safety net?

First, let's explore the fear of change. The hard-core fact is that digital change is on its way; it may even already be here! To begin addressing your fear of change, you must therefore decide what type of individual you want to be: *pro*active or *re*active.

Proactive individuals are eager to make changes that benefit them. They welcome change and are open to this force in the environment and in themselves. If you are a proactive individual and are reading this book, you are most likely

already using digital technology and will use this book as a guide to perfecting your already-implemented systems.

If you are a reactive individual, you most likely purchased this book because you have acknowledged the importance of digital imaging in your field and are ready to begin contemplating the steps and systems required to make this very important transition. If this sounds like you, congratulations! You have just taken the first step in overcoming your fear of change. If you're not feeling 100% confident yet, keep in mind that you don't have to banish all fear right away. After all, without fear, there is no passion. Without passion, you are unable to truly love your art. As Mark Twain wrote, "Courage is resistance to fear, mastery of fear—not absence of fear."

In order to reduce the fear of change, you must be able to momentarily suspend judgment and step out of your comfort zone. You must be able to let go of your opinions and positions when appropriate. You must also be able to listen to opposing views in order to discover the new possibilities that may be available to you. It is important not to let preconceived ideas get in the way of learning. Rather than approaching a situation with a "prove it to me" mindset, consider adopting a more inquisitive attitude, asking "What if this would work? What opportunities could this create?" Once you begin thinking "out of the box," an entirely new array of opportunities is revealed.

However, photographers that step out of their comfort zone do not typically stay com-

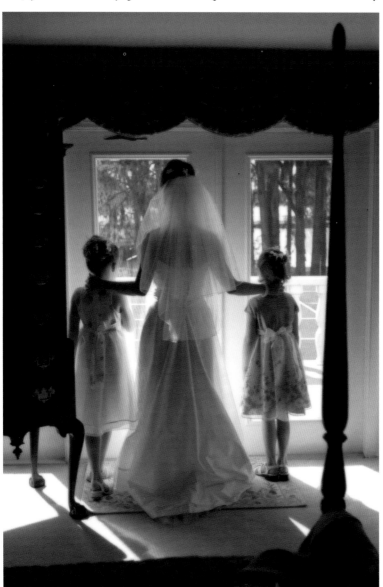

Follow your vision wherever it leads you. With a dream and a goal, all things are possible!

fortable for long! You have to commit to the change. You have to make a vow to yourself, establishing a clear goal and a strategy for making this transition. When will you begin the transition? When will the process be complete? After all, if you do not know the direction you are going and how long it will take you to get there, you will never complete your journey. Once you know what your goals are, it is easier to befriend your discomfort.

▶ PROCRASTINATION

Human beings normally procrastinate or create barriers as a means to avoid discomfort while completing a specific task. How do you know whether you are subject to this problem? Try this: observe your physical and emotional reactions as you visualize the following experience.

You are walking through a trade show with hundreds of vendors and you stop at the fifth booth to discuss a new technology. The vendor says he has the best camera available at a special price and you should try the following to get fabulous images. First, set the camera to capture in JPG fine mode with normal sharpening. This will give you about a 2.5MB file right out of the camera. Then set your white balance to sunny, which typical-

Take one step at a time as you follow your dreams. Don't settle for less—just continue to climb!

ly produces nice skin tones even indoors. Make sure you save it on a microdrive that has at least a 1G capacity—unless you would prefer using Compact-Flash cards, which some believe are safer. Whatever media device you choose, insert it into your PC via your card reader and copy your files to your client directory. When you begin the enhancement phase, you will convert the file to a TIF at 250dpi, size it to order and use

the Curves feature in Photoshop® to optimize the image. Add filters, color correct, batch number, eliminate noise, and burn your CD.

How did that make you feel? Did it sound like a foreign language? Are you feeling a little uncomfortable? Are you breathing faster or slower? Are your shoulders tense? Do you feel uneasiness in your stomach?

If that's the case, it's okay! Take a deep breath and stay with the discomfort for a little bit. Once you accept it, it is much easier to overcome and not as overwhelming.

▶ OVERCOMING DISCOMFORT

Now, begin getting past the discomfort by summoning the courage to begin changing your thoughts. You can make this transition. Have confidence in your abilities and don't feel intimidated. Once you learn its techniques and jargon, you'll find that digital photography isn't any more intimidating than film photography. The digital transition is not that difficult once you accept the changes

With an "out of the box," abundance mentality, you can do anything you set your mind to.

that are taking place and begin addressing them.

Next, acknowledge that change and transition are simply a part of any industry (and life itself), and that you must therefore be prepared to accept them. Taking advantage of the opportunities presented by technological change is an important factor in maintaining and building your business. For example, using a computer can certainly contribute to your business's success. While it will allow you to take advantage of digital technology, it can also contribute to your overall success and financial growth. Together, computers and digital technology make it faster and easier to process information and images, revise documents and provide more efficient and effective customer service for your clients. Obviously, these changes offer real advantages. By acknowledging this, you can begin to take your business into the new realm of photography.

▶ TECHNOPHOBIA

Dealing confidently with technological changes requires developing a level of comfort with the equipment you have selected. Are you technophobic (someone with a fear of machines and technology)? Perhaps you have never even used a computer before. If so, remember it is merely a machine, similar to calculators and cameras.

Some people handle stress differently than others. The above bride is an example of one of those people!

Actually, the process of learning to use a computer is not much different than learn-

ing to use a camera. When you initially begin using a camera, you typically learn the basics—what buttons to push, which lenses work for which types of images, and eventually different camera settings. However, you never actually have to understand the mechanics of the inner body or inner workings of the camera. To use the camera, you don't need to know where each wire goes, or how the microchips work, or how to repair it. If something isn't working, you simply send it off to be repaired. Likewise, you do not need to be a computer programmer to operate a computer and to work with digital equipment. Many very effective computer users learn only how to turn on their computer, utilize their favorite programs or software, and then turn it off again. For more difficult procedures, find a computer expert to assist you—just as you would an auto mechanic, a tax accountant, or a surgeon.

One technophobic (and self-sabotaging) objection often raised by photographers reluctant to make the digital transition concerns fear for the safety of digital images. Are you afraid of losing the acquired digital images? Do you view film as an archival safety net? If so, ask yourself these questions:

1. Have you ever lost a roll of film, or discovered a partial roll after the client already previewed the proofs?

2. Has the lab ever destroyed a negative?

3. Do you ever worry about negatives being lost in shipping?

4. Have you ever had an office assistant scratch, bend, step on or misplace a negative?

Because the original (and any number of duplicates) can be archived on CD, you'll never need to worry about losing a once-in-a-lifetime shot like this due to lost or damaged negatives.

If you have been in business for a while, you can probably answer yes to at least *one* of the above questions. With all these potential problems, film photography presents numerous risks of its own. Therefore, we will examine in future chapters how to safely capture your images and save them in triplicate. Then you'll never have to worry about losing, scratching, damaging or misplacing another negative!

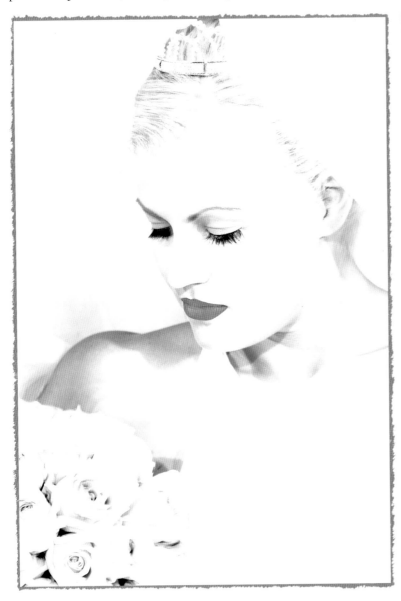

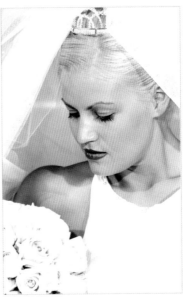

You don't need to become a computer expert to begin expanding your artistic vision and creating more distinctive images. (Above: Original digital photograph. Left: Enhanced digital photograph.)

CHAPTER 2

COSTS AND PAYOFFS

TO MAKE THE DIGITAL TRANSITION, YOU HAVE TO GET a little uncomfortable by stepping out of your zone with technology, overcoming your fears of change, working a little harder learning new skills and qualifications, and investing in new equipment. Those aspects of the transition make it easy to see the cause for hesitation.

But what makes this transition worthwhile? What are the payoffs? Typically, we choose to engage in new behaviors because they align with what we want most. What do you want for your business? Are you willing to let go of your fears and do what it takes to see it grow? You may be better able to answer those questions by reviewing the benefits and advantages of this digital direction, which are thoroughly discussed in the next segment.

By now, you have probably accepted that a change is on its way, and that (at the very least) you need to evaluate it with an open mind, apply critical thinking skills, and analyze the transition from more than one angle.

Being business owners ourselves, we have analyzed the advantages that come with making the transition to digital and are very excited by the results. Establishing a digital workflow will give you more creative control, increase your advertising, and lower a majority of your processing and proof expenses.

But what makes this transition worthwhile? What are the payoffs?

▶ CREATIVE CONTROL

The first benefit we discovered was the ability to regain creative control of our work. This in turn renewed our excitement for covering weddings. The gratification of being able to view the images right away proved to be a powerful advantage for both the photographer and the clients.

Have you ever gotten stuck in photographic rut? Have you ever rolled out of bed on a Saturday and thought to yourself, "Oh, please don't make me have to go to another wedding again!" While photojournalism captured our attention and fueled our creativity for a couple of years, even that can eventually become as mundane as the ritual of formal portraits.

With digital imaging, our photographic world has now become open to the endless possibilities offered by photo manipulation. We are no longer just capturing the images the day of the wedding and releasing them to a lab for processing.

We can now perfect our art to the fullest extent of our vision! We can control cropping and color, and correct common problems like low light situations, bad angles, unwanted people and props, imperfect faces—anything! The possibilities are endless and actually have the power to make you look like a photographic genius!

▶ ADVERTISING

The second advantage to making the switch to digital is the ability to expand your advertising by sending digital images to friends, clients and vendors. In our book, *Professional Marketing & Selling Techniques for Wedding Photographers* (Amherst Media, 2001), we reviewed the importance of these marketing tools. Due to our digital capabilities, we've seen improvements in our vendor relations (with stock advertising), community awareness (with reception-site displays) and customer service (with an expedited workflow and instant feedback).

Shooting stock photos (of rings, invitations, etc.) can help build vendor relations and is an excellent form of advertsiting.

▶ HINTS AND TIPS

A nagging question may still remain: If what you are currently doing is working, why can't you continue doing it the same way? The answer is simple. As the old saying goes, "If you do what you have always done, you will get what you have always gotten." Where will that put you five years from now? How successful would your business be without a telephone? What will happen if this digital transition affects our industry as abundantly as the telephone did?

For example, producing stock photography is now faster, easier and more effective. In our opinion, this new procedure is one of the best benefits to the digital experience. The fabulous advantage of digital photography is that you can save time and money when submitting stock images.

To get started, identify which vendors in your area would benefit from using examples of your photography. The businesses may include: bridal publications, florists, caterers, reception venus, etc. Previously, to provide a stock image to a vendor, a photographer had to rummage through proofs, pull negatives, send them off to the lab, have prints made, and then get them to the appropriate vendor. That requires a substan-

tial investment of time and energy. However, with digital photography all you have to do is place your digital images on-line (this simple process is explained in detail in chapter 10).

If the vendor chooses to display the images on their Web site, you can deliver the image to them on a CD. If a vendor prefers to add your image to their samples album, you can

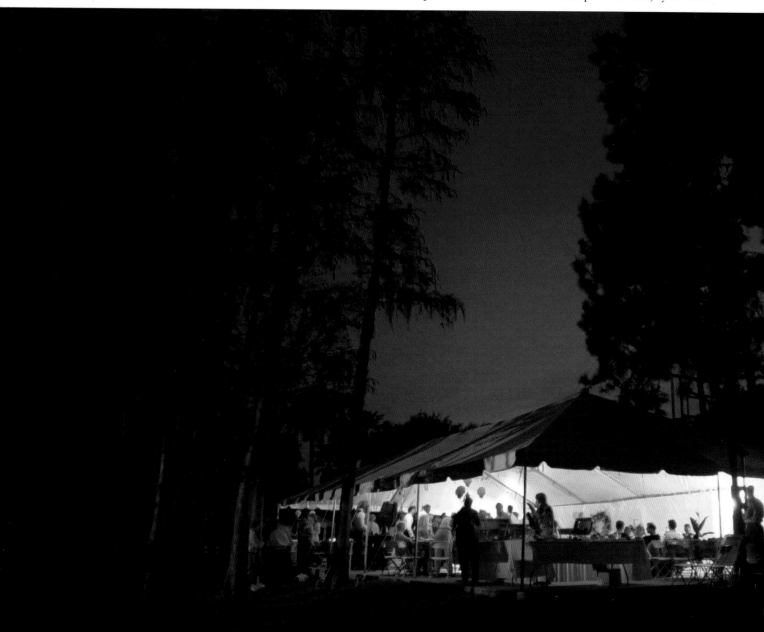

create a print for them using either your own printer or the services of a lab. As you get to know your area vendors, you will learn which method they prefer.

Regardless of the means by which you deliver the image, consider adding a photo credit (perhaps your Web site address or company name) to the front of the image. This can be added by using a simple Photoshop tool (additional information on photo manipulation is located in chapter 9). By avoiding the need to add a big, ugly address sticker to what is supposed to be a valuable work of art, you will add an elegant appeal to your photograph while maintaining the advertisement benefit.

Providing stock photography provides you with *free* advertising—an opportunity you should certainly take advantage of!

Another awesome form of advertising made possible by digital imaging is the ability to display your images of the wedding at the reception. This display increases community awareness of your business and boosts outside orders for portraits from the wedding. When

jeffhawkins.com

jeffhawkins.com

You can add a photo credit to the front of stock images using Photoshop. This will add an elegant appeal to your photograph while maintaining the advertisement benefit.

creating your reception display, there are three options. For a small-scale display, you can exhibit your images on a laptop computer. For a medium-scale display, use a television with an S-video connection. For a large-scale exhibit you can use an LCD projector to show your images on a screen. The steps and procedures required to create these displays are described in detail in chapter 7.

You do not necessarily have to charge for this display. We only charge our clients for this service if we are required to rent equipment or hire someone to set up an LCD projector and screen. There is no charge if the client has someone bring in and set up the projector and

screen—and you would be amazed at how many people actually have access to this technology! Our goal is to have a display at every wedding. We begin the display with the couples' names. Underneath their names is our company name and Web site address. We have a captive audience at every wedding. The images continuously recycle throughout the length of the reception, beginning with the clients' names and our information each time.

Lastly, a crucial enhancement to advertising is the benefit of instant feedback. Keep in mind that, if you are operating effectively, the majority of your business should be derived from referrals. With the instant feed-

back made possible by immediate results, both you and your client will be assured their day has been captured accordingly. When the couple and their families see how beautiful the bride looks or how handsomely you have captured the groom, the anxiety will disappear from their faces. Creating this relaxed and productive environment will, in and of itself, increase your chances for excellent referrals.

▶ WORKFLOW

With the use of digital technology, your workflow will actually speed up! You can anticipate developing a company timeline similar to the following:

Saturday/Sunday—Photograph weddings
Monday—Triple save images, prep for proofing
Tuesday—Create digital proofing videos and contact sheets
Wednesday—Place promotional images on-line, identify stock images, call clients and schedule album design
Thursday/Friday—Work on stock and digital album orders from prior designs

Using our previous film-based workflow, we would not even have had the images developed and processed for up to

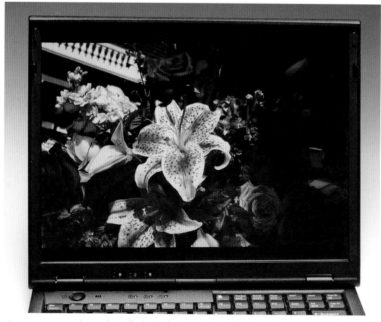

An awesome benefit of digital imaging is the ability to use a laptop or digital projector to display your wedding images at the reception.

With the instant feedback made possible by immediate results, both you and your client will be assured their day has been captured exactly as they want it to be.

two weeks—sometimes longer. With the new digital system, the proofs are ready for viewing before the client returns from their honeymoon. Many of our clients actually view a selection of their images while on their honeymoon—from digital cafes all over the world! This keeps the excitement alive and gets them passionate about viewing the rest of their images and designing their album when they return from their honeymoon. When they do return to design their album, this process allows them to have a final product in their hands six weeks (on average) from their special day! This quick turnaround time is a huge asset to your company.

▶ SAVINGS

The most lucrative advantage to digital imaging is the financial gain. After the initial equipment investment, the money you save in film, processing and proofing is substantial. By switching to digital (eliminating film, processing and proofs), we reduced our average monthly overhead by more than $3000. The only additional overhead you may incur is in shifted employee responsibilities. However, if this is carefully managed you could actually save money here as well! Therefore, with creative planning and financing, much of the equipment can essentially pay for itself within the first few months.

CHAPTER 3

INITIATING CHANGE

LOOK BEFORE YOU LEAP, BUT DON'T OVERANALYZE! Solid critical thinking skills—the ability to spot assumptions, weigh evidence, separate fact from opinion, and see things from more than one angle—are a valuable commodity to anyone in the wedding industry. They are also required when it comes to working with and selecting digital imaging equipment, and are especially profitable the day of the wedding.

Photographers characteristically fall into two categories when it comes to critical thinking: the "cheetah thinkers" and the "turtle thinkers."

▶ CHEETAH VS. TURTLE THINKERS

Cheetah thinkers jump in head-first. They see a situation, evaluate the scenario and conclude that they can conquer any obstacle that gets in their way. They realize and accept with confidence that they will have to battle prey. These cheetah photographers normally walk into a trade show and evaluate which booths they want to conquer then go after their objective. They purchase the newest equipment and begin using it right away. They overcome their obstacles as they discover them. They are do-it, get-to-the-point, handle-it creatures. They are also, typically, the most influential photographers in the industry. Many others linger in

Solid critical thinking skills—the ability to spot assumptions, weigh evidence, separate fact from opinion, and see things from more than one angle—are a valuable commodity to anyone in the wedding industry.

the landscape waiting to ascertain the cheetah thinkers' next moves.

On the other hand, turtle thinkers analyze *every* detail from *every* angle and take their time making decisions. They move rather slowly. They don't battle their prey, they walk around it. Turtle photographers, as a rule, pick up the trade-show program, carefully study it and identify the vendors they would like to see. However, they proceed to walk into the trade show and instead of just going to the booths they want to see, they start on one side and slowly, carefully go down each row. They are cautious not to miss a thing—analyzing each special product and promotion available to them. While turtle thinkers do eventually make the necessary transitions, they are typically not the first to make the move. They do it when they feel they can make a steady, easy-going shift.

It's not really important which of these you are, but be wary of *turtles* trying to be *cheetahs*—these are frightening creatures! These individuals want to be leaders, innovators and motivators in the industry but then overanalyze all their decisions. They often find themselves caught up in the "cheetah excitement" and buying all the

While the ability to create unique images like this is certainly exciting, it's important not to get swept away by it. Successfully making the transition to digital requires careful thought and planning.

latest equipment and technology available to them. Then, they take the turtle pace in putting their new purchases to use. Because of this, they incur a huge financial liability that does not generate the revenue it should in order to maintain a financially profitable business.

▶ PLANNING

We have discovered that the one kind of thinking that can profit both cheetah and turtle photog-

raphers is planning. Having a plan can channel your passion, your energy and your excitement into tangible achievements. Planning transforms your goals into realities. Every good, successful business has a marketing plan. Consider these suggestions for creating an effective plan:

1. Timeline—Plan a time to begin planning. Set aside time to create your timeline, and include your family or significant other in this process. Establish long-range goals for what you want in ten, twenty, even fifty years. Plans that extend past your lifetime are extremely powerful because they force you to create a target goal for the legacy of your business. From a digital perspective, identify when you want to purchase the equipment, when you want to begin the transition and when you want to complete the transition.

2. Create Measurable Goals—Business goals are specific changes you would like to make in your business. Determine how to translate that goal into an action. Determine the steps you will need to make to put these digital desires into action. Review the detailed steps in chapter 6 for ideas for implementation.

3. Write Out Your Plan—Share your plan of action with your employees and your family. Include them whenever possible. One of

the most effective ways to motivate an employee is to work them into the future of your business by painting a vivid picture with them in it. The digital transition can be a frustrating one for your staff. Their duties may change and their responsibilities may increase. If they feel as though they are a part of the company's future, they will be more tolerant of this transition. Furthermore, an effective way to gain your family's support is to paint a picture of the long-term benefits associated with the new goals. Initially, the digital transition may require additional time away from your family and friends. It is crucial to make them feel that they are a part of this new goal. Try working your plan from the future back to the present. Painting the benefit of the monthly processing savings can help persuade a family member to be more accepting of the investment in new equipment and the initial additional time required at the computer.

4. **Avoid Excessive Turtle Thinking**—A concise plan can have a powerful effect on your business. However,

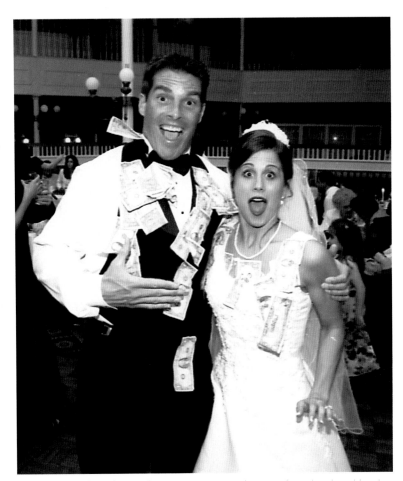

Going digital might not leave you covered in newfound riches like this couple, but you will enjoy a significant reduction in your processing and proofing costs.

be willing to begin even if your plan is not complete. An unfinished plan is no excuse to miss a powerful experience. As Henry Ford said, "Whether you think you can or you can't you are right!"

5. **Avoid Detours**—Stay focused and remember your goals. Things happen in life that can derail us from our endeavors—employees quit-

ting, marital strife and financial difficulties, to name just a few. If this occurs, just get back on track.

6. **Feel Free to Reevaluate**—You can change your plan. Sit down to do this annually. If you prefer, you can even do it more often. During these sessions, reevaluate where you are at the moment and where you are going.

**7. Planning Makes Change
Easier**—Planning your digital transition will alleviate unnecessary stress and anxiety. A plan will break the switch down into smaller pieces and make it easier to digest.

▶ SHARPEN
YOUR SKILLS

An important factor in your initiation of the transition to digital is gaining the knowledge required to take your business in a digital direction, much of which is covered in this book. However, to effectively make the digital leap there are two other important skills you should keep in mind. These are skills you have been blessed with from birth and skills you have picked up from the influences in your life. These two skills are often referred to as "adaptive" and "transferable." Understanding these can help you tailor your digital transition to suit your personality.

Adaptive Skills. Adaptive skills are skills you are blessed with from birth. These are the skills that make photography a joy for you.

If you like to photograph children and take family portraits, you most likely have a strong interpersonal adaptive skill. You probably enjoy work-

As you make the transition to digital photography, you'll need to evaluate your working and shooting style and determine how to capitalize on the advantages that will make it most valuable to you. For some, the ability to preview images immediately may be a primary advantage. For others, the ability to add after-effects may be of great importance.

ing with people and developing lifelong relationships. You are likely to embrace the way the immediate feedback of digital photography enhances your interaction with subjects.

If you specialize in commercial photography you probably possess a stronger detailed logical adaptive personality. You are likely to thrive on the technical equipment and capabilities of the digital trends.

A wedding photographer can go either way. Traditional wedding photographers are typically comfortable with "following the rules"—they have secure and stable adaptive skills. They confidently remember those rules, understand those rules and will create classic award-winning images over and over again using them. Wedding photojournalists, on the other hand, rebel against rules and

Depending on their style, wedding photographers will find different advantages to making the transition to digital imaging.

refuse to think inside the box. They usually have more of an adventurous, broader-thinking adaptive skill.

Transferable Skills. In order to stay competitive and successful, most of the above photographers have also picked up transferable skills from influential experiences or people in their lives. For instance, a photojournalist may decide to work in a traditional, formal style to please the mother of the bride, or the traditional photographer may become a photojournalist to meet the new trends and demands in their marketing demographics. The same thing happens when a photographer begins using Photoshop® to stay in competition with other local photographers by creating new and exciting products.

When making a change, it is important for you to identify the strengths and desires you possess and how you can use these to facilitate the transition. It is also important to use this knowledge to balance your business, surrounding yourself with other people who can assist you with the skills that do not come naturally. (Often, business owners hire people that are most like them, because they feel more comfortable with these types of individuals. In chapter 8, we will review the

importance of hiring different personality types to complement your weaknesses.)

If you enjoy working with people and developing relationships, you are likely to enjoy the immediate feedback of digital photography.

CHAPTER 4

EDUCATION

ONCE YOU ARE MENTALLY READY TO TAKE THE digital plunge, it is time to begin actually doing it. A good starting point for learning about digital products and how to use them is to consult national organizations and publications, and to attend seminars.

When joining an organization or professional society, you can meet people and get career guidance, too. To begin, try contacting:

▶ ORGANIZATIONS

National Association of Photoshop Professionals (NAPP)
www.photoshopuser.com
(727)738-2728

Professional Photographers of America (PPA)
www.ppa-world.org
(800)786-6277

Wedding and Portrait Photographers International (WPPI)
www.wppinow.com
(310)451-0990

All of these organizations can provide information on additional training and educational programs you can attend. It is especially important to learn as much as you can about Photoshop and photo manipulation software. This is becoming our digital darkroom and giving us a remarkable form of creative control.

A good starting point for learning about digital products and how to use them is to consult national organizations and publications, and to attend seminars.

Magazines like *PEI* (Photo Electronic Imaging) and *Rangefinder* can help you stay on top of new technologies.

▶ PUBLICATIONS

One can also learn about these fascinating new procedures by subscribing to the following magazines:

Digital Imaging Magazine
Cygnus Business Media
www.digitalimagingmag.com
(920)563-1769

Photoshop User Magazine
National Association of
Photoshop User Professionals
(727)738-2728

PEI
Professional Photographers
of America
(800)742-7468

Rangefinder
Rangefinder Publishing
Company
(310)451-8506

▶ ON-LINE GROUPS

Online groups may also be of use to you. Two of the groups we have utilized the most and have found to be very helpful are:

- www.robgalbraith.com
- www.dpreview.com.

▶ SEMINARS

Through the educational literature, monthly newsletters and e-mails of the national organizations you have subscribed to, you should be able to identify upcoming educational seminars that may be helpful to you. Attend as many of these programs as you can until you get comfortable with your procedures and implementing your own digital systems.

If you do elect to attend classes or seminars, consider these suggestions in order to gain as much as possible from the experience.

1. **Introduce Yourself to Your Classmates**—Get to class early or stay late so you can talk with them. If you do not understand a segment, your peers may be able to assist you. Study groups can also be very beneficial. If a group of photographers are attending the same program, they are likely to have objectives similar to your own. Acknowledge that and work together.

2. **Get to Know Your Instructor**—Instructors really do want you to succeed, so don't be afraid to ask for assistance. Most photographers and instructors enjoy sharing their thoughts and expertise. Get the instructor's e-mail address or phone number before the seminar has ended and ask permission to contact him/her if you have additional questions. Keep in mind, most speakers prefer being e-mailed with questions rather then receiving phone calls. E-mails can be answered at the speaker's convenience and not yours. Ask the instructor what he or she would prefer.

3. **Be Prepared**—Attend the class with the correct materials (pen, notebook, computer—whatever is needed). Sitting in the front center section of the lecture room has several advantages. First, it will improve your concentration and reduce the temptation to daydream. It will also make it more difficult to leave early or arrive late. Additionally, a front-row seat means there are fewer distractions between you and the instructor. Most instructors are not professional performers. If the information is technical and the instructor is, well—let's face it—a little boring, sitting closer may also make it sound more interesting.

4. **Pay Attention to Your Handwriting**—Paying attention to how you hold your pen and how neat your handwriting is can actually keep you focused on the class and shorten spurts of daydreaming.

5. **Turn Off Your Cellular Phone**—Be courteous to your classmates and allow yourself to focus. You can check your voice mail messages during the break. Since most photography instructors do not have a teaching background, distractions can be especially annoying to them and cause them to lose their important train of thought.

▶ MENTOR

Finally, consider finding a mentor in the industry. A mentor is an advisor or a coach. It may be someone who has an established business, or someone who is viewed as a master photographer or a Photoshop guru. A mentor can educate you not only by example, but also by giving you many pointers for making the digital transition. Learn from their experience and success.

SELECTING EQUIPMENT

ONCE YOU HAVE DECIDED UPON THE TRANSITION to digital, you need to assess the basic tools that will be required. What viewing software will you use to display your images? Will you be changing your proofing process? How do you plan on preparing your album designs? You will also need to contemplate other factors—such as what camera equipment, computer equipment and printers you will be using.

▶ MAKING SMART PURCHASES

After you have evaluated the above questions, begin investigating the options available to you. Research is imperative when deciding what equipment to use. Consider the following suggestions before making your purchases.

1. **Evaluate Your Budget—** This step should be accomplished in conjunction with creating your marketing plan. As you increase your expenses and liabilities, it is important to evaluate how you will increase your revenue-generating activities. Breaking away from film may take more time than you anticipate, so it is important not to rely on the savings from film and processing to cover your additional expenses. Evalu-ate where you need to spend

What viewing software will you use to display your images? Will you be changing your proofing process? How do you plan on preparing your album designs?

money first. Look at the most expensive tool you are contemplating purchasing and evaluate where you can cut back. This expense will have the biggest impact on your business.

2. **Shop Around**—Try not to be a cheetah thinker and buy the first item that appeals to you. Try to comparison shop by making phone calls and conducting Internet searches. Prices may vary drastically on big-ticket items. If you think like a CEO and evaluate a minimum of three options before each big-ticket purchase, you will save a lot of money and eliminate impulse buying. Examine all the possibilities at a trade show and then go home and evaluate them. Don't respond like a kid in a candy store! You are not buying bubble gum, you are mak-

ing a decision that will impact your business and your family.

3. **Get Your Feet Wet**—If you are inexperienced when it comes to computers and/or digital technology, begin by getting your feet wet. Purchase an inexpensive camera and see how it feels. Then practice, practice, and practice. This camera is not a wasted purchase—it could become a fabulous vacation camera or a great way to begin motivating and training one of your assistants. You can use the same procedure with your computer. Get referrals from a photographer in your area for a local computer programmer and network administrator. Get in touch with this professional and discuss a good "starter" computer. Ask him/her to recommend what would work best for you. The further you get into the digital process, the more you will identify and understand your personal preference and needs. You will probably also see the benefit of having more than one computer in your studio. Therefore, your starter computer will still be put to good use.

4. **Look for Quality**—The least expensive camera can cost you more money in the long run. Likewise, while older cameras may be more cost effective, they may not give you quality your business needs—making them a poor financial decision. Even though your clients may pick up their album and appear to be happy, if the work in the album is not up to your studio's standards, it could cost you your reputation. Your reputation in the community is far more valuable than the difference in cost between a low-end camera and a high-end one. When making quality decisions, ask to see the work of other digital photographers and compare the results achieved with different equipment.

5. **Pay in Cash**—As often as possible, avoid interest charges by paying cash for your new equipment. It may seem easier and less intimidating to pay for new equipment in monthly installments, however, the finance charge on many cards can be very high. This percentage can add up and get you in financial trouble during slower months of the year.

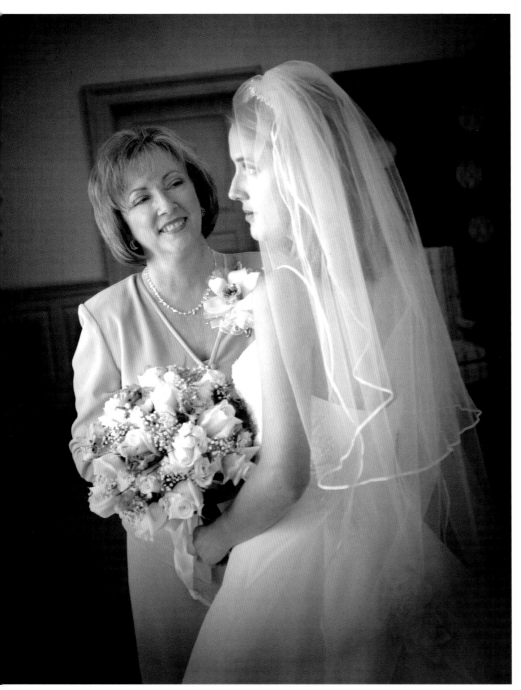

While camera features vary widely from model to model, image quality is the bottom line: look for one that consistently produces sharp, high-quality results.

6. Look for Incentives—Companies that are consumer-friendly will often have incentives available. For instance, some vendors include free software with the purchase of the camera. This software works in conjunction with their digital camera equipment to view, enhance and correct your images. Often the difference in cost between two cameras changes drastically when company bonuses and buying incentives are taken into account.

7. Set Limits—Limit your new equipment purchases to a percentage of your yearly revenue. Give yourself a monthly, quarterly or yearly limit. Once you begin this digital journey, you will see new "toys" every day. If you limit your spending to a set amount of your monthly revenue, the only way to purchase this exciting "gotta have it" piece of technology is to work for it—a great motivator!

▶ **CAMERA EQUIPMENT**

The three most important determining factors for selecting cameras are: features, specifications and pricing. Because

models and features are changing day to day, it is beyond the scope of this book to definitively recommend specific models or detail their features. However, based upon our research and communication with other photographers throughout the United States, the most popular cameras have many common characteristics: they offer features to make shooting easier, accept your existing lenses (minimizing investment) and yield sharp, high quality images.

CCD/CMOS. The CCD (charge coupled device) or CMOS (complementary metal oxide semiconductor) is a small photosensitive semiconductor chip onto which light is focused in the digital camera. The CCD acts as the "film," converting the image it captures into pixels. CCDs contain receptors (like exposure meter light sensors) that act as sampling points. The more receptors in the CCD, the higher the resolution and image quality will be.

CMOS chips serve the same function. While they are less expensive to manufacture (which can reduce the cost of the camera), they can present problems with noise and tend to

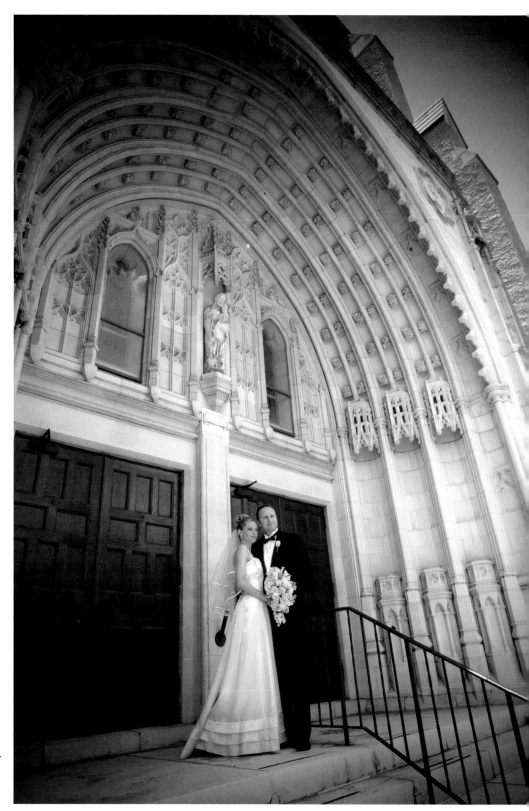

Since one digital shot costs the same as a thousand, you can experiment freely.

be less sensitive than CCDs. However, they require less power than CCDs, so CMOS chips can have a positive impact on battery life and reduce the number of backup batteries needed.

The size and quality of the CCD/CMOS determines the quality of the images you will be able to create and is a large fac-tor in the overall price of the camera. With increased CCD size, prices increase exponen-tially—however, so does image quality. Therefore, it is extreme-ly important to evaluate your needs before making a buying decision.

Image Storage. Images in a digital camera are stored in one of two ways: on a built-in memory device or on a remov-able memory device. If the images are stored on a built-in device, they can be transferred to your computer using a direct connection via a cable. Cameras with built-in memory are less expensive, but have drawbacks. For instance, once the storage device in the camera is full you must empty it (by transferring the images to a computer) before additional images can be created.

On cameras with removable media, the camera writes the image data to the removable storage device as you capture your photographs. This is a much more versatile system—when the media becomes full, you can simply eject it and insert a new one (basically like you would change film at the end of the roll). When you get back to your computer, the images can be transferred to your hard drive and the empty card can be reused.

Two common formats for removable media are Smart-Media cards and CompactFlash cards. CompactFlash cards have higher maximum capacities and more sophisticated electronics that make them more versatile. Higher-end cameras often fea-ture removable media called PCMCIA (or PC) cards. For all of these devices, drives are avail-able that allow you to connect them to your computer (much like a floppy drive) and transfer your images from the cards to your hard drive. Some printers are even designed to generate prints directly from removable media.

Below, you will find a list of important features that you should consider.

1. **Burst Rate**—The camera's ability to shoot images and process the information quickly is referred to as the camera's burst rate. The number of shots per second and the process rate varies from one camera to another. Most pro-sumer cameras can process 3–5 frames per sec-ond at full resolution and more at lower resolutions. Most professional digital cameras can burst 5–10 frames per second at full resolution, more at a lower resolution. The ability to

work quickly is especially important for wedding photographers. Because a wedding is an uncontrollable event, one does not have time to wait to capture a spontaneous image.

2. **Sensitivity/ISO Range**—A film with a low ISO is more effective in bright conditions; one with a high ISO is more sensitive and therefore better in lower light situations. In digital photography, the sensitivity is determined by the sensor (called the CCD/CMOS). One of the great advantages of digital technology is the ability to quickly alter this sensitivity at any time—meaning that you don't have to wait to complete the roll of film before making a change. Often, the higher the ISO the more noise will appear in the image.

3. **Shutter Response Time**—Shutter response time is commonly referred to as the "lag" time. This is the length of time between when you press the button and when the camera fires. Professional digital cameras typically have an acceptable shutter response time. The delay, however, will vary between models. The shutter response time will directly affect the camera's burst rate, thus reducing the photographer's ability to work quickly.

4. **LCD Panel**—An LCD panel is used for immediate image analysis. It should be large enough and sharp enough to allow you to see the image clearly.

5. **Lens Capability and Accessories**—Does the camera accept the type of lenses you want to use? Are the accessories you like available for it?

6. **Color Depth/Bit Depth**—The higher the bit depth, the more color information. The more color, the better the image. When shooting in raw mode (uncompressed images) with a professional camera, you typically create a 16-bit image, which represents millions of colors. When photographing in JPEG fine mode (compressed images), you typically create an 8-bit image, which may only represent several hundred colors. Both modes are effective, but a tremendous difference of color possibilities exists.

7. **Memory Card/PC Card Format**—These are the devices where images are recorded and stored in the camera. Their capacity and design have a great impact on the convenience of using the camera and the ease of transferring images to your computer.

The design and capacity of the camera's removable storage media has a great impact on ease of use.

8. **Dimensions/Weight**—As with any other camera, your digital camera should be one that you are comfortable carrying and shooting.

9. **System Requirements**—To take full advantage of the potentials of digital imaging, it is important that your camera (or its storage

FACING PAGE: Every little girl dreams about her wedding day. Staying on top of technology helps you make these dreams a memorable reality.

devices) and your computer can communicate efficiently.

10. Price—As noted on page 31, determine what you can reasonably afford and stay within your budget.

11. CCD/CMOS—The size of this image-recording device is a determining factor in the quality of your images. Currently, CCD/CMOS sizes in the most popular cameras range from 2.74 to 5.47 megapixels—and bigger is better!

▶ COMPUTER EQUIPMENT

As noted on page 33, it is wise to seek the advice of a knowledgeable expert when purchasing computer systems for your business. Some of things to discuss with your programmer (or perhaps your photography mentor) in regards to your computer equipment include (but are not limited to) the following:

1. Should you go Macintosh or PC?

2. How much RAM, hard drive space and processor speed are needed?

3. What features do you need to run your software?

4. Will you be able to upgrade at a later date?

5. What printers or modems will you need to purchase?

6. What are the dealer's policies on returns and updates?

7. Will any training be available on how to use the computer? Does it come with instructional materials? How easy is it to understand?

8. Will a high-speed modem be required to work with larger capacity images?

Keep in mind, you can purchase your computer anywhere, but be sure to get the fastest processor and highest amount of RAM you can afford. If you plan to do on-site displays at weddings, you'll also need a removable hard drive or a laptop with an S-video-out port for connection to a compatible TV or VCR.

Accessories. In addition to the computer itself, effective digital imaging requires numerous other components. These include:

1. **Monitor**—This is where you will see all of your images and do any needed retouching or creative work.

Therefore, it should be large (we use a 21" model) and offer high-resolution settings.

2. **CD Burner**—CDs are a convenient way to back up your work or supply it to others (important for successful stock photography). A burner allows you to create CDs easily.

3. **Hard Drives**—You'll need lots of storage space to store and manipulate your digital photographs. The more hard drive space you have, the easier your digital imaging will be.

There are countless other accessories that may prove valuable to you. For example, we use a tape-drive system to back up our data. A graphics tablet (a pressure-sensitive pad and stylus that replace the mouse) is very useful for accurate photo enhancement and manipulation, since it offers increased control. A colorimeter, a device used to calibrate the color balance of your monitor, printer, and scan-

ners, is also an extremely useful asset.

Camera-Related Software. Each camera has its own unique software that allows you to see the image as it's taken, and color correct it with the client. Kodak and many other camera manufacturers package their software with the camera. Nikon, however, currently charges for their software—but the benefit of being able to use our existing Nikon lenses and equipment outweighed this cost and made it financially advantageous for us to purchase a Nikon product.

Photo-Manipulation Software. This software will help you perfect your images. Two of the most popular and effective programs of this type are Adobe® Photoshop® and MetaCreations® Painter®. Both can be used for photographic manipulation and enhancement effects. These techniques are explored in chapter 9.

There are numerous other products that fit into this category and may be useful to you.

For example, Genuine Fractals® software is designed to resize images, while Vivid Test Strip® can be used for color correction.

Bibble® gives you the ability to easily apply exposure compensation and white balance corrections to JPEG files (white balance correction helps produce accurate colors). Bibble was originally designed to read the Nikon D1 (NEF) raw files and work in place of the Nikon® capture software. However, it now has added features to work with the Nikon D30 as well. This JPEG manipulation process makes this program worth having. Bibble also includes color correction and calibration profiles. Furthermore, tone compensation can be optimized to give you cooler images or to saturate them.

Next, the ACDSee®, EZ-Viewer® or Thumbs Plus® software are incredible browsers to use in conjunction with Photoshop. You can use them to rotate a display of images.

Other Software. Montage Pro® is designed to increase album sales and assist in image ordering. It is covered in detail in chapter 11. Windows XP Professional® has features for organizing and displaying your pictures for easy access. It also has software built right in to make copies of your files or

Be sure to update your software regularly. These important updates and program specifications should be found in the different educational media mentioned in chapter 4.

photos directly onto CD-R or CD-RW media. It has expedited and organized our workflow.

► OFFICE EQUIPMENT

Printers. Whether you select a color or black & white model, a laser printer is a valuable tool for printing of forms, Montage® storyboards, contact sheets and workbooks. You will also want this machine available to print your forms, letters and promotional materials. Color laser printers, in particular, do a fabulous job of producing professional-looking documents.

Additionally, inkjet printers, used by digital artists to create stunning art prints and notecards on watercolor or fine art media, are important for digital imaging. Be sure to select a printer that offers archival inks.

Currently, we utilize an Epson® inkjet printer and a Hewlett Packard® (HP) color laser printer. The inkjet printer is used for printing watercolor-type prints and notecards. With its archival ink said to last 200 years, this printer is a strong choice. The HP color laser printer is used to produce contact proofs, marketing materials and promotional flyers and other office tasks.

Be sure to shop around and investigate before buying. Cannon®, Epson®, Hewlett Packard®, Kodak® and Sony® all manufacture printers that are well worth considering.

Proofing Equipment. We are currently using proofing videos for our clients. This involves utilizing three video cassette recorders (VCRs) linked together, Microsoft® Power-Point® for title slides, a slide show program (such as Thumbs Plus®, EZViewer®, or ACD-See®), a television for monitoring and a video card that is used to send your images to the VCRs.

Creating your images digitally (using a digital camera) makes the particular process much more simple, since it eliminates the slow process of scanning negatives. Using your digital files, you can output your images to video tape, or print out contact sheets in color or black & white and place them in Art Leather's Digital Portfolio, or create a workbook and bind them together. If using the Art Leather Digital Portfolio, we would recommend you change the imprint on the cover to your own studio's logo. This will enhance your company's name recognition and eliminate any possible negative connotations your clients may associate with the word "digital." For only a few dollars, you can go to an office supply store and get the materials for a workbook compiled from your contact sheets, pricing info and order forms. (You can explore this topic in greater detail in the proofing section in chapter 10.)

Scanners. Many film-based photographers may elect to use a flatbed scanner to begin the digital transition. Scanners are used to electronically scan images to create a digital file. These digital files may be used for on-line ordering, proofing, or album design purposes. When you install a new scanner, it should be calibrated the same as your monitor and printer. See the color calibration section in

chapter 12. (For the very best results when scanning an image, consider purchasing a drum scan. Drum scans, due to the high cost of the equipment required, are usually done in commercial labs and are of higher quality than can be achieved with a flatbed scanner. They are, however, also much more expensive.)

Because digital technology changes so rapidly, purchasing decisions and education about new options will need to be made on a regular basis. To take advantage of the latest advances, it is necessary to continuously reevaluate the effectiveness of your existing equipment.

▶ HINTS AND TIPS

When shopping for printers and scanners ask yourself these questions:

1. What will you be using it for?
2. Will you be using the scanner to upload to the Web for on-line ordering, or will you be generating professional prints and need archival quality?
3. Will you be generating professional quality high-resolution images, or will you be using the printer or scanner as a proofing method?
4. Would a variety of printers and scanners be more cost effective for your business?
5. Should you consider a less expensive printer for proofing and low-resolution images and reserve your more expensive, higher-quality printer for professional jobs only?

INTEGRATING DIGITAL IMAGING WITH YOUR WORKFLOW

HOW DO YOU GET MOVING AND GO DIGITAL WITHOUT creating a digital disaster? Hopefully, once you have determined if you are a cheetah or a turtle thinker, you will integrate this process with caution. In order to adequately make the transition and integrate

digital imaging into your workflow, consider the following suggestions. First, update and evaluate your existing workflow. Next, begin planning for the integration. Lastly, whenever possible, avoid making detours!

Many of the previous chapters explored updating and evaluating your existing workflow. Ask yourself the following questions to make this practical evaluation.

1. Is your business taking advantage of the most current technology available?

2. Are you happy with your income?

3. Are you measuring up to your local competition?

4. Are your clients able to use on-line ordering?

5. Are you able to monopolize your market by rapidly providing stock to local vendors?

6. Could you get excited about receiving free advertising and Web site publicity?

First, update and evaluate your existing workflow. Next, begin planning for the integration. Lastly, whenever possible, avoid making detours!

7. Could you or your clients get excited about expediting your workflow process?

8. Do you think your customers would appreciate being able to design their album a week after their wedding day?

9. Could you benefit by showcasing your images to the guests on the wedding day?

10. Are you continuing to grow your business, or are you restrained by "stinkin' thinkin'" (also known as a bad attitude)?

▶ TIME MANAGEMENT

Once you have evaluated your existing workflow by exploring the answers to these questions, begin the integration. This requires planning—which, in turn, requires time and time management. Have you ever felt as though there was simply too much to do and not enough time in the day?

Consider this: there are 168 hours in a week. Technically, you should be able to work 40 hours per week, sleep 8 hours per night (56 hours in the week), spend 5 hours per day of uninterrupted family time (35 hours in the week), spend 4 hours per week exercising, and *still* have 33 hours per week left over to educate yourself and begin making the digital transition.

If that is true, then where does all your time go? The most important step to integrating digital imaging into your workflow is to analyze how you will spend your time, who will conduct what steps and procedures, and how much time you will spend in each category.

The first step is to analyze how you will spend your time. Many photographers spend hours on the computer, merging into the new millennium and eventually neglecting their business and family. This is a dangerous path to travel.

To begin tracking your time, faithfully use a personal weekly plan sheet. This does not necessarily have to be a calendar or an organizer—it can be anything that allows you to track your activities for production purposes. Consider using the highlighter or code system. For example, you could highlight in

▶ HINTS AND TIPS

When planning, you should always be realistic. Allow adequate time for each of your activities and plan for the unplanned. Do the tasks you dread first and get them out of the way. Procrastination is a road block on your digital journey!

yellow all the time spent on educational activities. Highlight in blue all the production time (work that is to be completed on past revenue-generating accounts; this time will not automatically bring you future revenue). Next, highlight in green revenue-generating activities such as interviews, weddings, photo sessions and album designs. Finally, highlight in pink personal or family time. No matter what your lifestyle is like, it is important not to work *all* day, *every* day. When someone is consumed by their business, they don't have much left to offer to others. A sample weekly plan sheet in included on page 47.

▶ DELEGATING TASKS

It is important to establish a balance for each of the categories. If you are not doing all of the aforementioned tasks, make sure to delegate them to someone else. Always ask yourself, "Can I make more money if I pay someone else to complete this task?" For example, if it takes you countless hours (or

even months) to figure out how to redesign your own Web site, was it financially advantageous for you to do it yourself? On the other hand, if you decided to hire a top-notch, high-end Web site developer and pay them $10,000 to redevelop your Web site, how many Saturdays would it take to recoup that money? Ask yourself: what is my time worth?

After you have delegated the tasks you feel confident in releasing and you are tracking your daily activities, make sure to prioritize activities and determine how best to spend your time. If you still feel like there are not enough hours in the day, consider adding fifteen minutes to your schedule by beginning each day earlier. Coming in just fifteen minutes earlier will add 1¼ hours to your digital week—basically an extra week each year!

▶ AVOID DETOURS

The last step in the digital transition involves the avoidance of detours. This is much easier said than done! The following tells you how we made the transi-

WEEKLY PLAN SHEET

WEEK OF ___/___/___ THROUGH ___/___/___

	SUNDAY	MONDAY	TUESDAY	WEDNESDAY	THURSDAY	FRIDAY	SATURDAY
7:00 A.M.							
8:00							
9:00							
10:00							
11:00							
12:00 P.M.							
1:00							
2:00							
3:00							
4:00							
5:00							
6:00							
7:00							
8:00							
9:00							
10:00							

tion. Keep in mind that we tend toward the cheetah-thinker model when it comes to technology. That said, you can probably guess that we jumped in head first! You'll need to decide whether you want to do it all at once or make the transition gradually.

Once you begin to see how digital imaging can set you apart from your competition, you'll see your motivation increase!

We began by doing a little research into the best system for us to start out with. Next, Jeff began studying basic photo-manipulation techniques. By the time we purchased our digital camera, he had a working knowledge of the new technology. After trying the new camera several times, Jeff felt that it would work sufficiently. Once he developed his confidence in the camera system, which he felt was the most important ele-

ment, he felt secure with using it to begin capturing weddings. Some of the important discoveries we made concerned the importance of having a file management system, backup batteries, backup microdrives and a fast laptop.

Because we made the transition as quickly as we did, sheer momentum (in part) kept us moving and gave us confidence that it could be done! Once we began, there was no turning

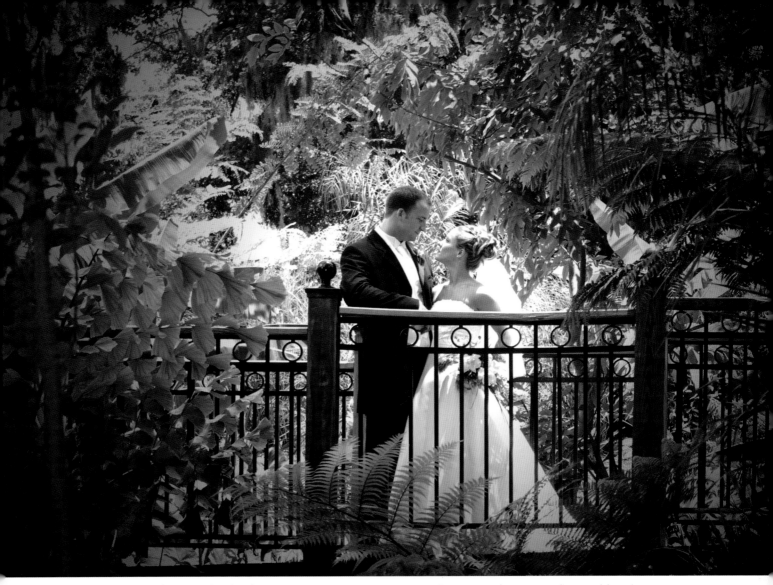

You can prevent disasters by backing up your images *immediately!* Bring your laptop to the wedding/ reception and back up your images throughout the event.

back! We realized that this transition could launch us far from the pack—thereby allowing us to offer our clients a more fine-tuned artistic product. If we had it to do again, however, we would seek more help from others and not try to figure it all out ourselves. Digital disasters can be averted with a little knowledge—and we have found that most photographers are happy to help, if you ask!

▶ HINTS AND TIPS

Backing-Up. You can prevent disasters by backing up your images *immediately!* Bring your laptop to the wedding/reception and back up your images throughout the event. Do not change or modify the image in any way until you have first saved it at least once. Without this step, it is easy to begin altering an image so much you forget what it looked like to begin with. Once the image is altered, there is no going back!

Developing a System. Having a system in place *before* heading out to photograph a wedding with your new digital equipment will spare you some severe headaches and anguish. For information about our process and procedures, see chapters 8–12.

MARKETING IN THE DIGITAL AGE

THERE WAS A TIME WHEN DIGITAL PHOTOGRAPHY represented low-end, quick-turnaround photos. Technology has improved and times have changed. If you want a superior cellular phone service, cable television or computer speed—you go digital. Likewise, if your

clients want superior photographs, they hire a photographer who can offer a state-of-the-art digital experience. In order to introduce your market to the digital age, you have to prepare them for this style of imaging, sell them on the advantages and adapt new selling techniques into your studio's routine.

Remember, you may be excited about your new camera and your new process, but your excitement may *not* be reassuring to your clients. Your new style may actually scare your

clients away rather than attract them to you—especially if you are not careful with the wording you select to use.

▶ BEGINNING THE TRANSITION

Begin this marketing transition indirectly, by introducing your digital images to your clients. In the beginning, your clients do not necessarily have to know what type of camera you are using. Before beginning this transition, did you feel compelled to educate them on your Hasselblad or the model of

In order to introduce your market to the digital age, you have to prepare them for this style of imaging, sell them on the advantages and adapt new selling techniques into your studio's routine.

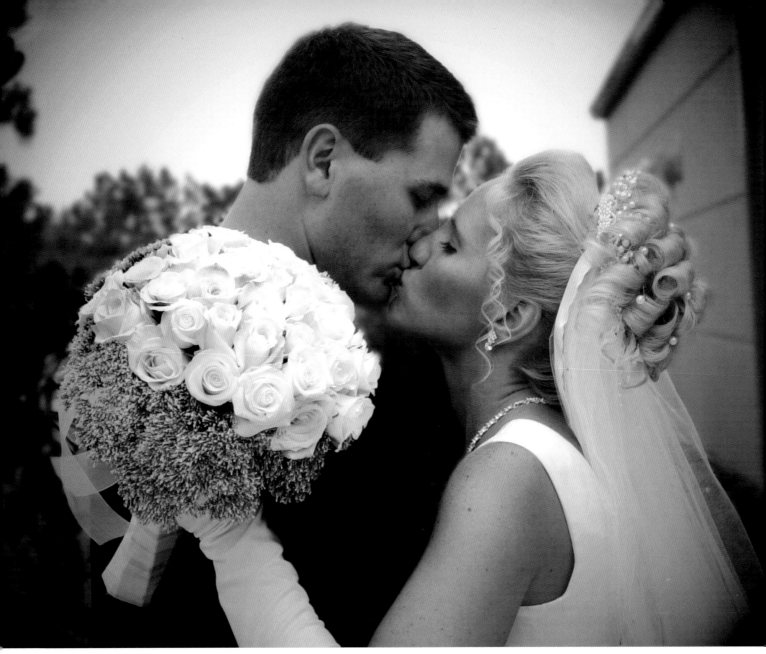

Nikon you were using? Most likely, you did not—it may have even annoyed you when they asked. If that's the case, why should the digital experience be any different? Once you feel comfortable enough with the camera, manipulation and printing techniques to create high-quality images, start showing different options at bridal shows and in your advertising.

At this point, people will begin taking notice of your new innovative product. You will have captured their attention without necessarily having mentioned the word "digital" in a sales presentation. You are selling the *results*, not the *jargon*. After you have begun preparing the bridal community, you begin educating the local vendors on the benefits of your

As you begin marketing digital imaging, be sure to sell the results (as above) and not the jargon.

studio's new technology. As a suggestion, send out an e-mail or a press release. You might consider wording your release as demonstrated in the following example:

Once you have begun the basic education and preparation of your market, you have begun the selling process. In order to successfully sell in the digital age, you should begin marketing in four fundamental stages. Perfecting these four marketing stages will assist your business in learning how to work full-circle. These stages include: pre-interview, consultation, wedding day and post-wedding day.

▶ STAGE ONE— PRE-INTERVIEW

The first stage is the pre-interview phase. This phase actually begins the moment you initiate preparing the community for the digital transition your business is endeavoring. Begin by showcasing a variety of digital images on your Web site, in your brochures and in your publication advertising. For example, consider displaying a watercolor image, a sepia print and an image with special effects or photo enhancements. Create a brochure that highlights some of your new features (see pages 53–54). Begin distributing this brochure to vendors and at bridal shows. Begin submitting stock photos to area publishers and vendors to be used in exchange for photo credit. This is essentially *free* publicity. It is not very time consuming and is extremely cost-effective. Brides will begin noticing your work all over town—your name should be everywhere they visit!

Continue using the convenience of today's technology and contact the publishers of local media. There are many wedding-industry publications that can assist you in getting your name out into the community. However, advertising alone does not make the most effective use of your dollars. Working the contact lists these publications provide you with is also *crucial*. (These lists contain the names, wedding dates and contact information for people who

Distributing your images to local vendors (florists, bridal shops and even wedding venues) will help to elevate your visibility among local brides—at a low cost to you!

Jeff Hawkins Photography

Top 10 reasons to book today!

cherish · *lifestyle* · *innocence*

1. Receive for FREE, all of your images archived on a Master File CD with the purchase of an album!

2. We do not have time limits, film limits, or set packages.

3. We have a new and innovative pricing structure, one that gives you the most flexibility in purchasing what you want. Let the pictures determine the size of the photo not the package!

4. We use State of the Art Technology using the top of the line 35mm, medium format, and digital camera equipment! Not to worry... We always come prepared with plenty of back-up equipment!

5. All of our bridal couples receive a Slide Show display of their images including the engagement session to showcase at the reception. You select the size of the display: 15 inch laptop display, television, or LCD Projector and screen!

6. Don't stress... have a blemish the morning of your special day! With State of the Art Computer Technology, Jeff Hawkins will perfect any imperfections! These images you will cherish for a lifetime!

7. When you hire Jeff Hawkins Photography, you hire Jeff Hawkins! You don't have to worry about a stranger photographing your important moment! Plus as a Double Bonus for you...you will always have the bonus of having a minimum of one often two, highly trained assistants with him! We can be in two places at once, if needed!

8. All of our couples receive on-line ordering. Make your life simpler and easier! No lugging heavy proof books all around town! Send them to your special website with your private password!

9. With our State of the Art Technology, our brides receive digital proofing. Making your life easier and saving you money! With no image limits... our average images in a wedding day ranges from 500 to 1400 images! Get complete coverage!

10. You are not alone designing your album. We care about the quality of our product. We realize this is most likely the first album you have ever designed. We won't leave it all up to you. All of our couples receive an album design consultation session, walking you through the design process. It is our goal to have your album designed and into production with in 2 weeks from your special day! You leave with a computer print out of what your final product will look like! This is a family heirloom. Let us help you make a storybook not a scrapbook!

fold

fold

sharing *gentle*

wedding relationist

jeff hawkins
photography

fold

Jeff Hawkins Photograpy
P.O. Box 151023
Altamonte Springs, FL 32715
407.834.8023
www.jeffhawkins.com

fold

personal

We look forward to the opportunity to speak to the two of you about your special day and to the possibility of making your memories last a lifetime! We take pride in developing a relationship that will last a lifetime. We don't want to be just your wedding photographer, we want to photograph your family in the years to come!

If you would like to quickly review our work, visit www.jeffhawkins.com.

Please contact us at (407) 834-8023 or 1-800-822-0816, to schedule a visit to our gallery.

Don't hesitate to call.... Dates do book up rather quickly!

Sincerely,

Jeff & Kathleen Hawkins

Photo by Ed Pierce

expressed interest in your ad and requested additional information.) In these days of electronic media, it is very effective to request your leads via the Internet. To avoid getting all your leads at once and not having enough time to effectively follow up with them, request that your leads are e-mailed to you on a weekly or biweekly basis. Next, delete the leads for the dates you are no longer available. The main information that you will need to print will include: name, address, e-mail address and phone number. Narrow your listing to the above items and print them on mailing labels.

At that time, you should prepare an e-mail (see samples below and on the next page). Save this "form letter" and personalize it for all the leads generated). This should be an introductory letter and should include your Web site address in the first paragraph. Including your Web site address will create a link for the prospective clients and make it easier to view your work. If you receive twenty

▶ SAMPLE E-MAIL LETTER 1: INTRODUCTION

Subject line: Please visit www.jeffhawkins.com

Jeff Hawkins Photography wants to be more than just your wedding photographer, we want to be your family photographer. All of our couples receive: customized pricing levels, unlimited time and images, on-line ordering, and the Lifetime Portrait Program membership! Featuring the work of an industry-sponsored, international award-winning photojournalist and published author, our studio can offer our clients all the latest technology. We create more than images—we create art! Let us capture your emotions, feelings, and relationships and document them for a lifetime. Remember, your wedding memories are not expensive, they are priceless!

Do not hesitate to call, as dates do book up rather quickly!

Best wishes,
Kathleen
Jeff Hawkins Photography
(555)555-0000

▶ SAMPLE E-MAIL LETTER 2: REPLY TO INQUIRY

Subject line: Please visit www.jeffhawkins.com

We recently received your wedding request and wanted to assist you as quickly as possible. We would love to work with you! I know that selecting a photographer can be an overwhelming experience. Let me help make this choice a little easier for you:

Top Ten Reasons to Book Jeff Hawkins Photography Today:

1. Receive a *free* Master File CD-R of all your images with the purchase of a Premier or Deluxe album. This is safer than negatives, which may scratch, bend, or be misplaced! With it, you can e-mail images to friends or archive your family heirloom.

2. You can become a member of our Lifetime Portrait Program.

3. We have a new and innovative pricing structure, one that gives you the most flexibility in purchasing what you want. Let the *pictures* determine the size of the photos—not the predetermined package! Typically, our custom levels begin at $2200 and our intimate weekday weddings begin at $750, however, each can be customized for your needs.

4. We use state-of-the-art technology featuring top-of-the-line 35mm, medium format and digital camera equipment! Not to worry—we always come prepared with plenty of backup equipment!

5. All of our bridal couples receive a slide show display of their images, including the engagement session, to showcase at the reception. You select the size of the display: 15" laptop display, television, or LCD Projector and screen.

6. Don't stress if you have a blemish on your special day—with state-of-the-art computer technology and Photoshop 6.0, Jeff Hawkins will

(continued on next page)

(continued from previous page)

eliminate any imperfections, creating images you will cherish for a lifetime.

7. When you hire Jeff Hawkins Photography, you hire Jeff Hawkins! You don't have to worry about a stranger photographing your important moment! Plus—as a double bonus for you—you will always have the benefit of having his highly trained assistant(s) on hand. This means we can be in two places at once, if needed!

8. All of our couples receive on-line ordering. This makes your life simpler and easier, since you won't need to lug heavy proof books all around town! You can even direct all of your friends and family to your special Web site with your private password.

9. With our state-of-the-art technology, our brides receive digital proofing. With no image limits, our average images in a wedding day ranges from 500 to 1400 images! This means you get complete coverage.

10. You are not alone in designing your album. We care about the quality of our product and realize this is most likely the first album you have ever designed—so we won't leave it all up to you. All of our couples receive an album design consultation session, walking you through the design process. You'll leave the session with a computer printout of what your final product will look like! It is our goal to have your album designed and into production within two weeks of your special day. This is a family heirloom; let us help you make a storybook, not a scrapbook!

I look forward to the opportunity to speak to the two of you and hope to hear from you soon. If you would like to quickly review our work, our Web site is located at www.jeffhawkins.com. Furthermore, you can also preview our work in both *Orlando Bride* magazine and *The Perfect Wedding Guide.*

Please contact me at (555)555-0000 or (555) 555-0001, if you have any questions or concerns— or to schedule your consultation. Remember, your wedding memories are not expensive, they are priceless! We hope to hear from you in regard to your wedding photography. Do not hesitate to call, as dates book up rather quickly!

Sincerely,
Kathleen
Jeff Hawkins Photography

leads a week, after deleting the dates you are not available, it should only take a few minutes to respond with an e-mail to your prospective clients. This places your company in front of most of your competition.

Lastly, use the printed address labels to send promotional postcards (see page 57) or brochures to the clients—especially those that did not list their e-mail addresses. Typically, we prioritize sending brochures to prospects whose wedding dates are in months we want or need to book. Then, we send postcards to contacts whose weddings are in less crucial months.

To recap, the first stage in the marketing process is making sure that prospective clients:

1. See your work in businesses everywhere.

2. See your photo credit in local bridal publications.

3. Receive a brochure highlighting the digital difference.

4. Receive a personalized e-mail highlighting your studio's dynamic distinction—and a convenient link to your Web site.

5. Schedule a visit to the gallery/studio.

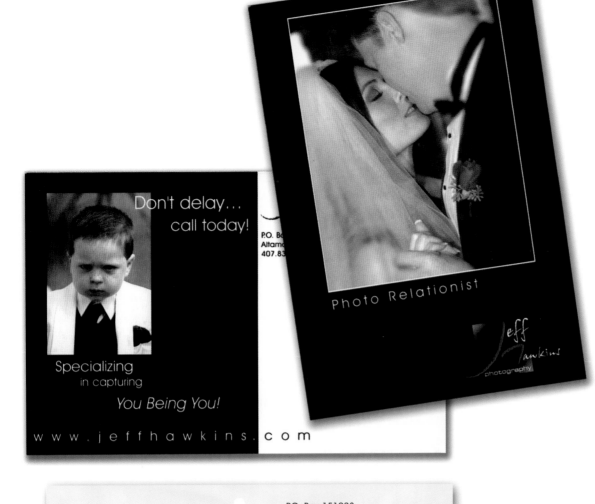

Don't delay...
call today!

P.O. Box
Altamo
407.83

Specializing
in capturing

You Being You!

w w w . j e f f h a w k i n s . c o m

Photo Relationist

Jeff Hawkins
photography

Thank you for considering Jeff
Hawkins Photography. We look
forward to sharing your special
day with you and making your
memories last a lifetime.

P.O. Box 151023
Altamonte Springs, FL 32715
407.834.8023

congratulations
on your
engagement

Jeff Hawkins photography

www.jeffhawkins.com

Jeff Hawkins
photography

The second stage in the selling process may very well be the most crucial—the interview. Your client has seen your work, spoken with you over the phone and is now ready to make a decision about hiring your services. This is the most important stage of the money-making process.

Presentation. At this stage, *what* you say may not be as important as *how* you say it. Consider these digital blunders:

BLUNDER: **"We are a proofless studio!"**

BETTER: *"Our state-of-the-art digital technology allows us to offer you more convenient proofing methods. All of our clients receive three different proofing options. You will receive on-line ordering for your family and friends, you will receive three duplicate digital proofing videos (one for you and for each set of parents to keep), and a professionally bound contact sheet with each edited image numbered for reference. This means you don't have to worry about lugging around or shipping heavy proof books! Our couples find this to be easier and more convenient."*

Implying that you are "proofless" is like telling the clients that they receive *less* with you than with photographers who use traditional proofs. You do use proofs, you just don't use paper proofs. Doesn't the second option sound more appealing than the first? With this improved presentation, it appears as though your clients are receiving *more*, increasing the value of your studio's work.

BLUNDER: **"We are completely digital!"**

BETTER: *"Our studio has a variety of 35mm, medium format and digital equipment. As an award-winning artist, our photographer will use whatever camera is most appropriate for what is being photographed. Don't worry, we have plenty of backup equipment! That is one of the main benefits to hiring an experienced studio."*

Again, doesn't the second option sound more appealing? Unfortunately, many couples have been misinformed by people or bridal publications about digital imaging. They believe that you are using the same digital camera as their Uncle Bob. If you have backup equipment, the above statement is 100% accurate. If something should happen and the digital cameras are not working accurately, then

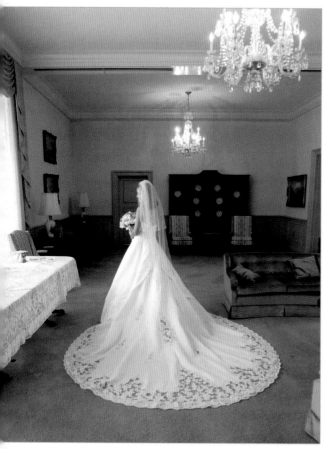

BELOW AND FACING PAGE: You will find that many prospective clients have been misinformed about the quality they can expect with digital imaging. Showing them your top-quality images can help alleviate that fear.

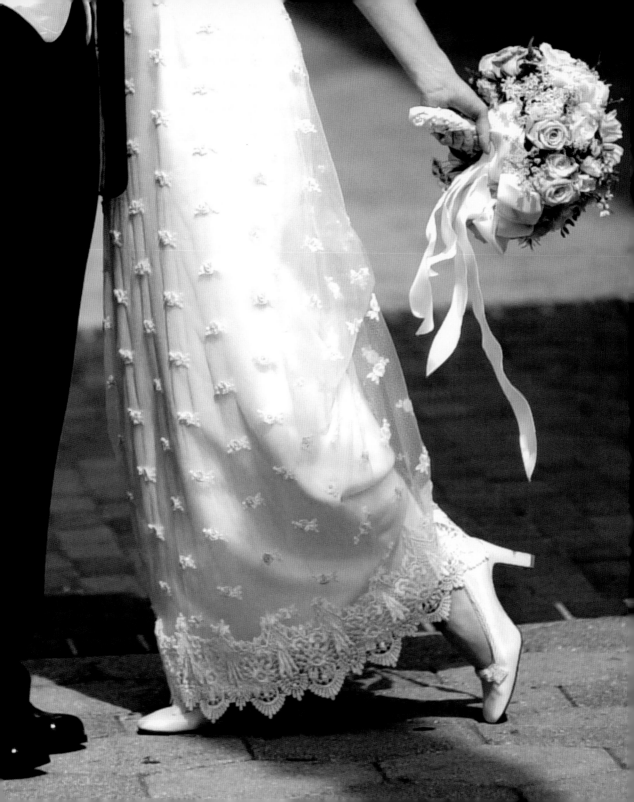

we would switch to a film camera. Although you may be completely digital 99% of the time, by selecting your wording carefully you can overcome potential objections about camera selection and backup equipment. The key is to overcome the objection before the client even asks the question!

BLUNDER: **"Oh, I can have that done in a minute—I'll just print it out on my printer!"**

BETTER: *"Let me see what our production schedule looks like and how quickly we can get that into processing. I will do my best to get the order processed as quickly as possible for you."*

Clients still find comfort in knowing their images went through a magical chemical process. They are often more skeptical about the digital printing process than the camera itself. The easier it seems for you to produce their print, the more you depreciate the value of your image. If they do require an expedited process, communicate that you have made an exception in the workflow (and never get it done *too* quickly). It may only take a few minutes to create a driver's license photo but it takes more than that to create a work of art!

As the quality of printers rises and the cost falls, clients are increasingly familiar with (and in ownership of) these high-quality items. Therefore, it is best not to reveal too much information about the printers you use. Leave these specifications unstated unless a client should directly ask for this information. Make sure you also address the issue of archival quality, even if the client doesn't ask about it. This also helps to convince clients that they could not create an identical image themselves. Your entire process from image capture to presentation should be a magical work of art—a special talent that only you possess!

Top Ten Reasons. After the client has had the opportunity to complete our client questionnaire and interview sheet, we explain the top ten reasons why people hire Jeff Hawkins Photography. This information is also included on our brochures and on our Web site.

In order to develop your own "top ten (or three or five) reasons" list, stop and evaluate your competition. When we created our list, there were essentially three photographers in our area who created healthy competition. One was very good, but very inexpensive.

One was priced right, but gave away the negatives and had a cookie-cutter approach to the albums. The other was a popular studio, but farmed out the clients to other photographers in the area.

Next, analyze what makes your studio unique. For example, our studio has more technology and equipment than any of our competitors. Second, Jeff has an exceptional ability to blend traditional, photojournalistic and photo-relationist photography. Finally, we have a variety of customer-service-oriented systems and procedures in place. However, ours is probably one of the most expensive studios in town.

After analyzing the above considerations, we knew what objections we would need to overcome and what we needed to sell in every interview. Many photographers like to believe their images sell themselves, but unfortunately they don't. Rather, the client has to accept and believe in the perceived value of your product. This can be achieved in the following manner:

Image + Money = Perceived Value

Based on this idea, the top ten reasons we developed are listed below and are discussed with

clients at the beginning of every interview. Also included are statements called "trial closes." These questions, all designed so the client can hardly help but answer yes, are designed to get the client ready to say yes to the big question—the decision to sign a contract with you. Reviewing each of these "reasons" helps us to head off potential objections from our clients and sets us apart from our competitors by educating the consumer as to what makes us unique. These benefits are always discussed before price is even mentioned!

1. We have no time limits, image limits or set packages. This statement tells clients that we don't believe in the cookie-cutter approach to wedding photography. We will photograph as many images as needed and personalize their time and product to their specific event.

TRIAL CLOSE: *Do you see how, since your day starts at X o'clock and ends at X o'clock, that extra time can benefit you?*

From dressing to departure, one of the features we emphasize is that we cover all of the wedding day—with no time limits.

2. We have a new and innovative pricing structure.

This lets clients know we offer flexibility—the ability to purchase what they want. Each level of coverage is customized to fit the couple's unique needs. They may want quality and not necessarily quantity, or they may be real picture people. We have so much confidence they will love the images, that it makes no difference whether they hire us at the basic level and buy à la carte for the album images, or whether they choose a much higher level of coverage.

TRIAL CLOSE: *How big of a "picture person" would you say you are?*

3. With the purchase of a Premier or Deluxe album, our clients receive their images archived on a CD.

We let clients know that this CD is much safer than negatives, which may scratch, bend, or be misplaced. Many of our clients use the images as screensavers, in thank-you notes, or even to e-mail images to family and friends. They can use the CD to print very small images, but we let them know that we take their images through about four more professional processing steps. Therefore, I always encourage our clients to contin-

With a Premier or Deluxe album, couples receive their images archived on a CD. This is elegantly presented to them in a custom case that adds to its value.

ue to have their professional images printed through the studio—but the CD is great to have for archival purposes!

TRIAL CLOSE: *Do you have access to a computer? Can you see the importance of both of us having a backup copy of such an important family heirloom?*

4. You do not have to worry if you have an imperfection the day of the wedding!

Since we take the time to take each image through a digital conversion process, our brides don't have to worry about having unwanted blemishes, exit signs, etc., appearing in their photographs.

TRIAL CLOSE: *Can you get excited about being able to* remove unwanted exit signs or blemishes?

5. When you hire Jeff Hawkins Photography, you hire Jeff Hawkins.

We let our clients know that they don't have to worry about a stranger photographing them on their important day. Plus, as an added bonus, they know Jeff will always have at least one (often two) highly trained assistants with him. Because of this, our brides know that we can literally be in two places at once, if needed.

TRIAL CLOSE: *Can you see the value of knowing who you are going to be working with prior to the wedding day and knowing that they will not be working alone?*

6. We always come prepared with plenty of backup photography equipment.

We use state-of-the-art technology with top-of-the-line 35mm, medium format and digital camera equipment.

TRIAL CLOSE: *Doesn't it make you feel comfortable to know that we will come prepared with more than one camera—just in case it is needed?*

7. With our state-of-the-art technology, our brides receive an "Image Reflections" display to showcase at the reception, plus digital proofing.

This makes our clients' lives easier and saves them money. With no image limits, we shoot an average of 500–1000 images on a wedding day, so the client gets complete coverage.

TRIAL CLOSE: *Wouldn't you rather have the problem of having too many images to select from than not enough? Don't you think your parents would appreciate being able to select from traditional color images as well as the artsy Giclée images you enjoy?*

8. We offer on-line ordering.

All of our couples receive on-line ordering. This makes their

Small announcement cards are distributed to the couple's friends and family, inviting them to order images on-line. This spares the couple from lugging a heavy proof book around town.

lives much simpler by eliminating the need to lug heavy proof books all around town. Instead, the couple can simply direct their friends and family to a special Web site. With a unique password assigned to the couple, the site can only be accessed by the people they want to see their photos.

TRIAL CLOSE: *Wouldn't you rather send your friends and family a note with a Web address instead of having to ship proof books all around the country and collect their orders? You don't have to be the middle man—let them come directly to us to place their order.*

9. You are not alone in designing your album.

We care about the quality of our product. We realize that their wedding album is most likely the first album our clients have

ever designed—and that can be stressful. Therefore, we don't leave it all up to them. All of our couples receive an album design consultation session, during which we walk them though the design process. It is our goal to have their album designed and placed into production within two weeks from their special day. After the design session, the couple leaves our studio with a computer printout of what their final product will look like. This is a family heirloom—we can help them make a storybook, not a scrapbook.

TRIAL CLOSE: Do you see the importance of using the photographs to capture a story like this book did?

10. We understand the importance of developing relationships with our clients.

We do not just want to be our clients' wedding photographer, we want to be their family photographer. All of our brides receive an honorary membership card to our Lifetime Portrait Program (see page 71). With this card, anytime for the rest of their lives (or ours), they can come in and receive complimentary pregnancy, baby, family, business or graduation sessions—all the important moments in their lives! (Portrait

dates, times, and locations are subject to availability.)

Trial Close: *Do you plan to have children someday? Well, there is no expiration date on this offer. We want to be able to make a children's album for you one day, as well. Typically, the fees run from* $200 to $350 for each session, depending on the image type and number of people that are photographed. These sessions would now be free to you. Of course, you can add à la carte items from there!*

When we finish discussing this list, it's time for the final trial

With our album design process, clients know they won't be on their own when it comes time to design their album.

ABOVE AND FACING PAGE: From their wedding guestbook to their family's future, we let our clients know we don't want to be just their wedding photographer—we want to be their family photographer.

close: Based on the services and quality of photographs, can you see the benefit of hiring Jeff Hawkins Photography? The client's answer: "Yes!" Your response: "Great! There's only one question then—what level of service do you want? We understand the importance of quality and can also respect your finances. We want you to have a high quality product, and will work with you in every way possible. These are your choices . . . (list options). Which would be better for you?" Then, go for the close and get the retainer.

▶ STAGE THREE— WEDDING DAY MARKETING

You sold your services, but the marketing should not cease the day of the wedding. You can now make the digital difference and generate a refreshing amount of excitement about your images. This is done by creating an "Image Reflections" display at the wedding, by promoting the 20/20 customer service program at the reception and by selling pre-reception parent and bridal-party gifts.

Our "Image Reflections" display is enjoyed by the couple and their guests throughout the event.

Digital Slide Show at the Reception. First, begin marketing the "Image Reflections" display during the interview. This is an inexpensive way to increase the perceived value of your services. The client has three display options for their images: a laptop, an SVHS compatible television (if provided by the venue), or an LCD projector and screen. If the LCD projector is provided by us, rental and setup charges will apply. However, if the LCD projector and screen are provided by the client, there is no additional charge.

To create the slide show, follow the steps listed below. Typically, the slide show setup begins at the start of the first course of the dinner. Your goal should be to have it running by the time the meal is complete.

1. Turn on the laptop.

2. Insert your media device (i.e., micro-drive, CompactFlash card) into the PCMCIA card.

3. Insert it into the computer PC card slot located on the side of the laptop.

4. Create folder with the client's name on both the FireWire drive and the computer's hard drive.

5. Copy the images from the media card to the new folder. (*Important!* Use the copy command, not the move command! That way, if there is a failure or a computer glitch, you will not lose any files and the images are protected twice.)

6. Once the images are copied, open the folder in a viewing program—such as Thumbs Plus®, by Cerious software (www.cerious.com).

7. Quickly edit the images, removing any photos where the subject blinked, there are exposure problems, etc.

8. As necessary, rotate images in the hard drive folder into a vertical orientation.

9. Begin the slide show by clicking the slide show button located on the menu bar.

Don't add music—you don't want to compete with the entertainment. This is just a continuous display for people to enjoy. The bridal couple will love to see their special images—it's instant gratification. As they watch, the bridal party and guests become more animated. After all, everyone loves to be seen on the big screen! For elderly people, who are often tired and have had a long day, this also provides an option other than dancing. They usually watch in awe of the technology.

Next to the "Image Reflection" display, include an assortment of on-line ordering cards (see illustration on page 63). Make sure these cards are styled to appear as gifts from the bridal couple, and not as a blatant publicity piece from your company. This helps maintain your upscale appeal.

▶ HINTS AND TIPS

As previously suggested, creating an on-line ordering system is indisputably the best way to profitably capitalize on the flow of traffic onto your Web site. The on-line ordering process consists of two steps. First, you want to be able to distribute cards on the wedding day. However, you don't want the excitement to wane after the wedding day. This decline can be combatted by successful post-wedding day marketing (see page 66).

Custom-Framed Gifts. At least a week before the wedding, be sure to promote a custom-framed gift collection. Consider the following suggestions to up your sales.

For example, you can create a "Daddy" frame. (We find the Art Leather large Futura frames in wine, silver or onyx to be the most popular choice.) This gift is purchased prior to the special day. Give the bride a gold, silver or bronze pen and let her personalize it for her father. Keep the mat in the frame box and bring it to the reception. Next, select one of the photographs from the father/daughter formals or the father/daughter dance. During the reception, when you have taken all the dance images you can tolerate, print out one of these images at a 5"x7" size on your printer. We have found it much easier to delegate this task to an assistant, but have also managed to find the time to do it ourselves when needed. Trim this photo and place it into the frame, then drop it into a gift bag with tissue paper. *Note:* In order to present their special gift at the reception, we have established a minimum purchase of three frames. This minimum covers the cost and time of setting up the printer and preparing the client's special gift on-site.

When the bride is ready to exit, have her signal you to get the gift and photograph the presentation. You have now increased your sales with the $100+ purchase of the framed image and by creating additional images for the wedding album. These images could include: bride giving gift to Dad, Dad opening gift, Dad with tears in his eyes, Dad hugging daughter, Dad holding the frame with daughter and son-in-law. This idea also works well for multiple presentation to both sets of parents, siblings, the maid of honor, etc. Bridal party folios are also big sellers.

Finally, if the couple is on a budget and elects not to purchase a gift collection, think about contacting one of their

To create a "Daddy" frame, we bring the bride's personalized frame to the reception. With an on-site printer, a selected image from the wedding (or reception) is printed and inserted into the frame. The gift is then ready for the bride to present to her father!

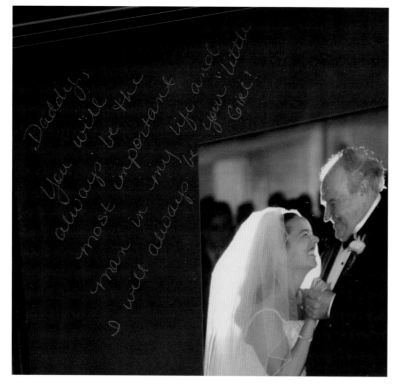

parents or the bridal party members and selling them a large Futura or Deluxe Futura frame. Create a signed mat and print an 8"x10" family portrait or bridal party portrait for them to take on their honeymoon. This is just one way to let the couple know they will be thought of while they are away!

Remember, this production should be done behind the scenes. No one needs to know how long it takes or how difficult it is to create your work of art. Famous chefs wouldn't reveal their secret recipes, so why should you?

These are just a few examples of how, with digital technology, you can now offer more, advertise more and make more money!

▶ STAGE FOUR— POST-WEDDING DAY MARKETING

To capitalize on the advertising gain of promoting our on-line images at the wedding and to draw traffic to our Web site, we have created a post-wedding day marketing program. This increases Web site activity, educates consumers about our services and increases our company sales.

20/20 Vision. We include in our basic-level service a program called "20/20 Vision." This is a customer-service program that gives the clients a minimum of twenty images on-line and twenty on-line image cards to distribute in thank-you notes to guests who were unable to attend. These images are on display within the first week after the wedding date. Often, our clients visit Internet cafes around the world on their honeymoon to get a sneak peek at the images from their special day!

Once the couple designs their album and picks up their proofing videos and contact sheets, they have the option of purchasing a program to display all of their images on-line for up to sixty days.

On-Line Proofs. Attempt to offer a program to your cus-

tomers charging them for placing their proofs on-line. Create a specific price for placing engagement proofs on-line, and an additional price for wedding images.

We suggest that the number of the images, the selection of the prints, and length of on-line visibility be selected at the discretion of the photographer. In this way, you are able to select what is displayed, how long it will be displayed and how much it costs. For more information on on-line ordering, try contacting www.morephotos.com.

The cost for this type of service is minimal and the response can be incredible.

Today, many couples can distribute an e-mail to all of the guests who shared their special day with instructions on how to view their images. If the old method of proofing is the only option, it is very unlikely they will ship proof books to every guest who attended their special day! As a result, you will miss out on sales that going digital could have generated.

As a review, in order to market with digital finesse, you must begin by introducing your market to the digital age. In this introduction process, you will cultivate a style of digital selling. Prepare your clients for the wedding day benefits, and adapt new selling techniques based on the digital technology.

► HINTS AND TIPS

Now that you are offering a state-of-the-art digital experience to your clients, you need to begin implementing the digital process into your daily workflow. Beginning during the reception, here is the procedure we follow to deliver images to the client:

WEDDING DAY
1. Download images from camera to laptop and FireWire hard drive.
2. During dinner, get ready for slide show.
3. Begin continuous play slide show on TV, laptop or LCD projector during reception.
4. Print up and package gift items (frames, etc.).

MONDAY
1. Prepare CDs immediately.
2. Download images to main computer from the FireWire hard drive and delete laptop folder.
3. Copy images into work folder (work folder is used for video and Montage® design). The

original files are not touched until image ordering takes place.
4. Create a numbering system broken down into sections.
5. Personalize images with photo-manipulation software.
6. Create three duplicate digital proofing videos.

TUESDAY THROUGH FRIDAY
1. Display a minimum of twenty images on-line (for "20/20 Vision" promotion).
2. Notate and stock photos for vendors.
3. Send client an e-mail notifying them that their images are on-line and recommending that they schedule an album design session. Leave a telephone message, as well.
4. Work on previously-completed Montage® album design orders.

At Jeff Hawkins Photography, we understand the importance of developing relationships with our clients. We want to be your family photographer.

As a member of our
Lifetime Portrait Program...

You can come to Jeff Hawkins Photography anytime for the rest of your life (or ours) and receive complimentary portrait sessions. Including: baby, family, school, anniversary, business sessions, all the important moments in your life.

Whatever that special moment in your life... we want to be there to capture all those precious events.

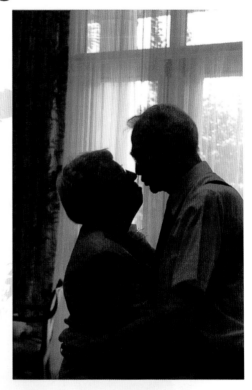

407.834.8023
www.jeffhawkins.com

Portrait dates, time, and location subject to availability and determined at the discretion of Jeff Hawkins Photography. Additional Product purchased a la' carte. Travel fees or minimum product purchase may be required based on the location, number of people to be photographed, and type of session desired.

CHAPTER 8

PHOTOGRAPHING DIGITAL WEDDINGS

THE FIRST STEP IN THE DIGITAL PROCESS IS ACTUALLY photographing digital weddings. Based on first-hand knowledge, it is much easier to photograph 100% digitally than 50% digital and 50% film. Having already made the switch to digital, thinking about returning to the old film way makes our heads ache and stomachs turn. In order to competently capture digital wedding day images, be prepared with adequate pre-wedding day planning, as well as technical and organizational modifications to your company.

▶ PRE-WEDDING PREPARATIONS

First, let us examine pre-wedding day preparations. We believe in the proactive, not reactive, approach to wedding day preparation. The process that works for us involves verifying and discussing three different checklists prior to the big event. The three lists include: a client checklist (page 74), a wedding day worksheet (page 75) and an equipment checklist (page 76).

Client Checklist. Next, the client checklist is reviewed to make sure we have all information required prior to the event. This important information includes preventing malnourishment (not eating is often one of the biggest complaints photographers have about photographing weddings). If you

In order to competently capture digital wedding day images, be prepared with adequate pre-wedding day planning, as well as technical and organizational modifications to your company.

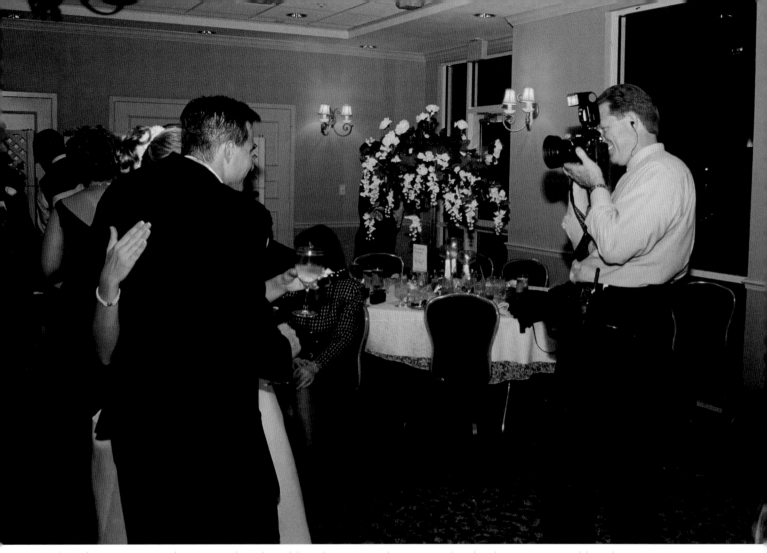

In order to competently capture digital wedding day images, be prepared with adequate pre-wedding day planning, as well as technical and organizational modifications to your company.

don't discuss it diplomatically, why should they think about it? They have enough other things to worry about during this hectic time in their life! The information sheet is typically completed one week before the wedding when the final balance is due. At the time of completion, we collect payment for our services and discuss any possible concerns.

Wedding Worksheet. The wedding worksheet is used as a tool to create vendor cama-

raderie the day of the wedding, and good public relations afterward. Distribute this form to your clients prior to the wedding day—perhaps at the time of the contract signing. Then, follow up with them to make sure they complete and return it to you before the big day. Use this form to send a small selection of stock images to the vendors who contributed to the success of the day!

Equipment Checklist. An equipment checklist should be

developed based on the equipment and products your company uses. This checklist will help you prepare as much as possible and eliminate possible disasters. Have your assistant or associate photographer complete a checklist prior to each event.

CLIENT CHECKLIST

1. Client name: _____

2. Wedding date: _____

3. Wedding day emergency contact number: _____

4. Pre-ceremony location:_____ **5.** Time: _____

6. Bride will be ready by (time): _____

7. Ceremony location: _____

8. Reception location:_____

9. Begin time: _____ **10.** End time: _____

11. Flowers will be delivered by (time): _____

12. Directions to pre-ceremony location: _____

13. Describe any planned reception exits: _____

14. Will there be a TV or a table available for "Reflections" display? _____

15. If using the "Gift Collection" program, will there be a 6' table set up as far away from the guests as possible to avoid congestion? _____

16. If the event is more than five hours long, will food be provided? _____

17. If food will not be provided, will an hour break be available? If so, at what time?

From_____ to _____

18. Special requests: _____

19. Balance due one week prior: $ _____

❑ Check # _____

❑ Cash _____

❑ Card number: _____ exp: _____

Date paid: _____

Thank you for allowing us to be a part of your day!

WEDDING WORKSHEET

Please complete and return the following information.

1. The Wedding of _____ and _____

2. Location: _____

 Contact: _____ Phone: _____

 Officiant: _____ Phone: _____

 Address: _____

3. Reception Venue: _____

 Contact: _____

 Phone: _____

 Address: _____

4. Caterer: _____ Phone: _____

 Address: _____

5. Cake: _____ Phone: _____

 Address: _____

6. DJ: _____ Phone: _____

 Address: _____

7. Band: _____ Phone: _____

 Address: _____

8. Other Entertainment: _____ Phone: _____

 Address: _____

9. Videographer: _____ Phone: _____

 Address: _____

10. Florist: _____ Phone: _____

 Address: _____

11. Limo: _____ Phone: _____

 Address: _____

12. Tuxedos: _____ Phone: _____

 Address: _____

13. Wedding Dress: _____ Phone: _____

 Address: _____

14. Wedding Consultant: _____ Phone: _____

 Address: _____

Please attach an itinerary of the reception activities.

Any special requests? _____

EQUIPMENT CHECKLIST

Inspected by:_____

Date:_____

Client name:_____

ITEM:	CHECKED:
Equipment instructions	❏ Verified present
Two (2) Nikon D-1x cameras	❏ All functions working, settings matched
Five (5) EN4 batteries for cameras	❏ Fully charged (if batteries have not been used you will want to recharge)
Two (2) MH-16 chargers	❏ Verified present
Four (4) 1G microdrives	❏ Drives erased and ready for use
Quantum Q flash-2	❏ Verified present
Six (6) Quantum Turbo batteries	❏ Verified present
Quantum Q-Pac OF36	❏ With remote head and charged battery pack
Six (6) Quantum Free Wire Digital Transceivers	❏ Wireless flash sync and camera triggers
Four (4) Bogen light stands	❏ Verified present
One (1) Bogen 3051 tripod with 3047 head	❏ Verified present
Two (2) White Lightning flash units	❏ Verified present
Metz colored gels	❏ Verified present
Metz 60-CT4 flash on a light pole	❏ Ensure battery is charged
Sekonic L-508 light meter	❏ Verified present
Laptop computer	❏ Verified present
PCMCIA adapter for the microdrives	❏ Verified present
Three (3) Motorola Talk-About two-way radios all with earpieces	❏ Verified present
Several packs of AAA batteries	❏ Verified present
Backup sync cords	❏ Verified present
Duct tape	❏ Verified present
Tools (flashlight, needle-nose pliers, screwdrivers, etc.)	❏ Verified present
One (1) large soft Tamarac case on wheels	❏ Verified present
One (1) Pelican 1620 hard case on wheels	❏ Verified present
One (1) 30G FireWire hard drive	❏ FireWire cable present

In addition to developing and reviewing the above checklists, executing problem-free digital wedding photography also requires you to analyze your company's technical and organizational practices and to determine how these may need to be realigned to take advantage of digital technology. For instance, retraining your assistant/associate photographer is an important aspect of this transition. Once you have taught your associate the new computer technology, the storage device requirements, and the benefits to this modification and you both feel confident in your duties, the employee will become a valuable asset to the organization. Furthermore, reevaluating your photographic style and how it may change from film to digital is also crucial. Lastly, consider the important steps and techniques required for photographing digital weddings.

Assistant Training. Begin your reorganization by taking the steps required to retrain and remotivate your assistant/associate photographer.

If you are not currently using an assistant, you should strongly consider doing so.

Once you have taught your associate the new technology and you both feel confident in her duties, the employee will become a valuable asset to the organization.

When making the decision, evaluate precisely what an assistant would be used for and how having an assistant could actually make you *more* money (rather than being an expense). For example, an assistant would be a valuable asset to have if she frees you up to concentrate on your passion—photography. To that end, the assistant could take care of all the equipment at a wedding, download the images to the laptop and prepare them

for the slide show, handle the supplemental lights (i.e., room lights and the light she will carry). The assistant could be made responsible for packing and unpacking the vehicle and maintaining the equipment on site. All of this will allow you to direct your own time to the actual photography.

When retraining (or training) this assistant for your digital transition, remember that they will likely be just as intimated about the switch as you were—possibly more so. Refresh yourself on the first few chapters of this book and understand that, although you have overcome them, your staff will still need to address these same fear factors. Their insecurities begin with the fear of losing images and end with the fear of losing their jobs! Instill confidence in them with the power of training and positive reinforcement.

To begin, sit down with your assistant/associate photographer outside of the wedding environment and educate her on preparing a slide show and beginning the download procedures required to transfer and save files from a microdrive or storage device. Then practice, practice, practice—take a few fun photographs and work through the process. Do this several times, until it is instinctive and natural.

Finally, reward your assistant with a new title, perhaps Associate Photographer, and let her begin having fun! If your assistant is working for you because photography appeals to her, giving her a camera is like taking a kid to a candy store.

Toward the end of the reception, begin teaching her the photography style and skills required to cover the event. This provides a great motivation for aspiring photographic assis-

tants. Additionally, with this training, the assistant can provide double coverage that doesn't cost the studio anything. This practice has allowed us to be more creative and free to document all the day's activities. It also allows the primary photographer to spend some time shooting for stock—again, at no cost. Additionally, this can prove as a great marketing tool since you can promote your ability to be in two places at once if needed.

If your studio only has one digital camera at the moment, consider using two-way radios with earpieces. Then, after you have comfortably captured what you need and the slide show is up and running, your assistant can "play" a little at the reception without being out of communication with you.

Again, as you make your transition to digital, make sure you understand your assistants' fear factors, overcome their worries with training and development and motivate them to succeed.

The next step to analyzing and adapting your studio's technical and organizational process involves reevaluating your photographic style. How might it vary from film to digital?

► HINTS AND TIPS

Handle your portable digital image storage devices with care! Teach all those involved with the shoot not to bang, drop or throw a storage device. Don't put them in your pocket or leave them lying around. Purchase a separate pouch that will be used only for the storage device. Make sure everyone involved understands that these devices are a valuable commodity—they contain family heirlooms that need to be cradled and cherished. Your storage devices contain your images (the digital equivalent of your negatives). If you lose them or erase them, the images are gone!

Although it might not be obvious, your shooting style *will* change because of the number of images you can shoot, the quality of the images and the ability to preview images.

With digital photography, you will save money on film and processing costs. With this factor out of the way, you will most likely expose more frames. We typically expose 500–1000 images at every wedding.

Additionally, the ability to preview images instantly means that, if you do not like an image or exposure, you can delete and capture it again. This ability also allows us to experiment more freely with creative lighting, setups, time exposures, silhouettes, etc. Further creative controls are offered by the ability to switch easily to black & white mode or to a higher ISO when shooting in a low light situation.

There are many different aspects to photographing digitally, and some of these are determined by camera selection. For instance, consumer-type digital cameras are typically slow and offer only limited control over shutter speed, aperture, white balance, sync feature, etc. Such cameras are probably a poor choice for photographing weddings.

Our camera of choice is the Nikon D1x. It features a 5.47

▶ HINTS AND TIPS

Noise. Noise can be defined as the visible results of an electronic information error from a digital camera. Visible noise in an image is often influenced by:

• A higher ISO rate (film-speed)
• The temperature (high=worse, low=better)
• The length of exposure (longer exposure=worse noise)

Raw Mode. Should wedding photographers photograph in raw mode? The answer to that question depends on the camera selected.

Some cameras don't give users the option to alter the mode. Shooting in raw mode requires the use of a software program that can decipher the raw code and allow the photographer to read the raw files. From that point, you can then convert them to another mode in order to edit and save the files. If you shoot in the raw mode, save the raw files as these are the original images.

Other cameras give you the option of shooting in the "JPG Fine" mode. This is the mode we recommend. Shooting in JPG mode creates smaller files, so you can save more pictures on the storage device. It also doesn't take as long to write the file to memory and allows you to work faster. The drawback is that the JPG compression can compromise the image data as it condenses the file.

megapixel CCD (creating a 4024x1324 pixel image) and offers a top shutter speed of 1/16,000 second as well as flash speeds up to 1/500 second. It will currently capture up to three frames per second for up to nine consecutive images—which is faster than most wedding photographers will probably ever need. The ISO range is 125–800, but can be tweaked in the camera's settings up to 1600. With the ability to white balance to different lighting situations (which can change often in wedding photography), this camera is a very valuable asset.

▶ GETTING STARTED

When converting to digital coverage here are a few tips to assist you in getting started on the wedding day.

1. Once you have selected your camera, use it to supplement what you are presently using. Try different settings, such as black & white mode, different ISOs, different aperture and shutter

Because you can instantly preview each of your images, capturing effects like backlighting becomes much easier.

combinations. Remember, it's not costing you anything!

2. Upon returning to the studio, evaluate what you have accomplished. Study the differences and learn from what you have done. You will learn there is not a major difference in film versus digital cameras—except that with digital you can see instantly what you have done and, if you discover that an image is not to your liking, you can redo it. Think about it—you're at the first dance, you're capturing the couple from all angles and maybe using your assistant to backlight them. You see that the background light is not bright enough or that your on-camera flash misfired. With digital, instead of waiting a week or two to see that you blew it, you can adjust the lighting and move on.

3. Make sure you have enough camera batteries. When you first make the change, you will be looking at the LCD screen a lot. This drains power.

4. Invest in backup media—CompactFlash cards and microdrives. If you experience a malfunction, you can simply switch. In wedding photography, the number one rule is always have a backup.

5. Learn as much as possible about Photoshop. Join the National Association of Photoshop Professionals (NAPP). If there is a class or lecture in your area, go to it. You will never learn all that Photoshop can do, but there are many techniques and tools you will use every day. Once you discover what the end result can be, you will begin setting up photographs during the wedding—with a very artistic outcome in mind.

6. As a rule of thumb, expose with your digital camera as though you were shooting transparency film; it's better to slightly underexpose than to slightly overexpose.

CHAPTER 9

POST-WEDDING IMAGING

T HE SPECIAL DAY HAS COME AND GONE AND YOU HAVE captured it. Now what do you do? The post-wedding day procedure is the most crucial step in digital wedding coverage, but can also be the most rewarding—both artistically and financially. The post-wedding day

procedures allow you to extend the artistic process past the actual wedding day. In this chapter, we will explore three important procedures: saving the images, creating special effects and beginning the digital proofing process.

► SAVING YOUR IMAGES

When images are captured on your digital camera they are stored on a removable media device (like a CompactFlash card or microdrive). It is recommended that you have at least

two or three 1G microdrives. If you use CompactFlash cards, you'll need even more units, since they have less space.

From that point there are several options. First, you can copy these images to your computer's hard drive (or a FireWire hard drive) and delete the images from the portable storage device so that it is ready to use again. If you do this, make sure the images are fully copied to your hard drive. *Always use the copy command and* not *the move command*—if there is a power surge or computer glitch

The special day has come and gone and you have captured it. Now what do you do? The post-wedding day procedure is the most crucial step in digital wedding coverage, but can also be the most rewarding.

during a move command you could lose files. If you prefer not to erase the removable media, make sure it is stored in a safe location in your camera bag or on your person.

This transfer can be made to your laptop during the wedding, or later when you return to your studio. If you don't copy the images to your laptop on site, you can just keep shooting. Just remember, whichever route you take, the storage device contains your images— if you lose it or erase it they are gone! If you won't be transferring the images to a laptop during the wedding, you may want to use a separate removable storage device for each phase of the wedding (one for pre-ceremony, one for ceremony, one for reception, and one for formals).

When you return to the studio, we have found the following procedures to work the best. Since we have no negatives to process, we move directly to the computer. The first step is to make a backup of the original image files using a Zip drive, Jazz drive or CD burner. This is done for reassurance only and most likely will not be used.

Next, we transfer the files from the laptop or storage media to the client's subfolder, which is in a wedding folder on our main computer. Once you are *positive* that the files have all been copied correctly, you may delete them from your storage media or laptop. When the transfer is complete, open the files in a viewing program such as Thumbs Plus® or EZ-Viewer®. After the files load, review them and delete the ones you do not like—those with the subject's eyes shut, bad exposures, etc. (If you have an image that is great except for a simple flaw that can be fixed, stop and fix it before creating your proofs. Keep in mind, however, that these are the original images. Make permanent changes at this point only if you are prepared to delete the image! If you mess it up, there is no going back. However, if it is unsalable the way it is, it couldn't hurt to try to make it better.)

At this point, you may wish to make a copy of this folder of original images. Place this copy in another location on your computer for safety purposes. Name it "client's name/back-up" (for example: Johnson/backup).

The next step is to number the images and begin the digital proofing process. Our numbering system has proven to be very reliable and a great way to keep up with our images. The system is based on series numbering. That means we have categorized the images into scenes (i.e., pre-ceremony, ceremony, reception, formals and engagement images).

1000–1999 pre-ceremony
2000–2999 ceremony
3000–3999 reception
4000–4999 formals
5000–5999 engagement

With this system in place, if you need to find a ceremony image when doing your album design, you would go to the 2000-series numbers and begin your search.

This numbering arranges your files in a chronological, storybook manner. This is recommended and will help you in the album design process. First, create a separate folder for each

In Thumbs Plus®, you will need to enable five spaces in the Automatic File Rename palette (only four spaces are normally enabled).

series—1000, 2000, etc. Then, go through your files and select the files you want to use for the 1000 series and move them into the 1000 folder. Once the images are moved it makes it easier to see what you have left to work with. Follow the same procedure with the remaining categories, moving the ceremony shots into the 2000 folder, the reception shots into the 3000 folder, etc.

In each of these folders, you can then organize the images the way you want them by numbering each file in the order you prefer. We prefer to auto-rename the images starting with 1000, 1001, 1002, etc. If you make a mistake and delete a file, remember you still have your

original folder so you are okay. Just copy the file you need from your original folder into the folder where you need it. If you overlooked a file, thinking you were finished, determine where you want the file to go in the sequence and place it there. For instance, to place an image after 2009 but before 2010, simply name it 2009a. The computer will place it in the correct order. (In Thumbs Plus®, you will need to enable five spaces in your Automatic File Rename palette to accomplish this. Normally, you need to enable four spaces because you have four digits (1000, 2000) but 2000a has five digits. If you forget this step, it will not allow you to rename.)

Once you have all your files in the series folder, your original client folder ("wedding/smith") should be empty. Move all the images back into the empty folder. Now, all the files in the folder will be in order. Copy all the numbered images once again to create the "client work folder" and begin the digital proofing process. Begin by burning a CD, and making sure that all the images were copied correctly. While the client folder on the hard drive could be deleted at this point, we typically leave it in place until the videos are complete, the images in the work folders have been digitally retouched/manipulated, and images are on-line.

To recap, here is the procedure, given step by step for your reference:

1. Create a folder for your original files.

2. Create a backup folder (if CD has not been burned).

3. Create series subfolders (i.e., 1000, 2000, 3000, etc.).

4. Select and move appropriate images to each subfolder.

5. Number the files in the appropriate order using the auto-renumber function.

- Check the interface between your computer and the device from which you are transferring images before moving any files.
- To avoid losing additional information, choose the no compression setting when transferring files.
- After transferring images, double check them on screen before deleting them from your camera.

6. Move the numbered images back into the original folder.

7. Copy the renumbered images to the work folder for backup.

8. Burn a CD.

9. Send to creative department or photographer for digital manipulation.

10. After the images have been manipulated and resized, burn a CD of the work folder.

► SPECIAL EFFECTS

Once the images have been saved, organized and stored you can begin the next phase of the digital process: personalizing your artwork. Now it is time to add pizzazz to your portraits and become the best photographer you can be! These post-wedding day procedures allow you to extend the artistic process past the actual wedding day. In this segment, we will examine how to create basic special effects to make your images outshine those of your competition.

To begin, look through the client work folder and identify images that appeal to you artistically. Your objective is to select five or six images that you can slightly modify to make your images picture perfect. The creative enhancements we use most often are as follows:

1. Convert the image to black & white.

2. Convert the image to sepia.

3. Create a vignette using the spotlight effect.

4. Convert the image to a watercolor.

5. Make the image part black & white, part color.

Layers. As you begin working with your image in Photoshop, consider working in layers to increase control and make it easier to correct your mistakes. A layer is a duplicate copy of the image stacked on top of the beginning image. This is similar to working with film transparencies; if you stack one transparency on top of another you can see both images. If you made an error and wanted to take away the changes on the top transparency, you could just remove it. The same applies to Photoshop layers. If you make an error, you simply remove it and start again. Similarly, if you like your alteration and want to apply it to the original image, you can basically discard the data from the underlying layer by flattening the image.

Creating a Copy of the Background Layer

1. In Photoshop, open an image from the work folder.

2. Go to layers palette.

3. Click on the background layer to activate it.

4. Drag the layer down to the "create new layer" icon and release.

5. Click on the new layer to activate it and begin the manipulation process.

6. After the manipulation process is complete (see examples below), go to Layer>Flatten Image.

7. Save and close the image.

The following are step-by-step procedures for creating many of the most common effects used in our wedding photography. Keep in mind, however, that Photoshop is only as limited as you imagination. You may want to start with these procedures, then develop additional ones on your own.

Convert Images
to Black & White

1. In Photoshop, open an image from the work folder.

2. Go to Image>Adjust> Channel Mixer.

3. Activate the "monochrome" box at the bottom right of the palette. You can then accept the image as is, or adjust it.

5. To adjust, simply move the sliders. To maintain the original brightness and contrast, the values of the sliders must total 100% (for example, if the red slider is set to +70% and the blue

slider is at +0%, then the green slider should be set to +30%). Adjust to your preference.

6. When you are happy with the result, click OK.

7. Save and close the image.

The original color image (right) was converted to black & white. The photo was also cropped and a vignette was added. The final image (above) is much more dramatic.

Convert Images to Sepia

1. In Photoshop, open an image from the work folder.

2. Go to actions palette (if this is not visible, go to Window>Show Actions).

3. Under default actions, locate sepia toning and click on it.

4. At the bottom of the actions palette, hit the play button (triangular arrow pointing to the right).

5. To adjust the intensity of the sepia toning, go to the layers palette. Notice the three layers available: the background layer, layer one, and a hue/saturation layer. Double click on the histogram icon in the hue/saturation layer.

6. Adjust the saturation to your liking.

7. Save and close the image.

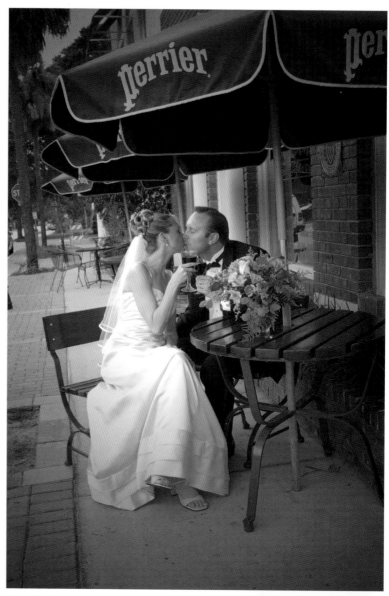

The flexibility to turn a color image (right) into a classic-looking, sepia-toned one is a valuable tool.

Create a Vignette with the Spotlight Effect

1. In Photoshop, open an image from the work folder and copy the background to a new layer (see procedure on page 84).

2. Go to Filter>Render> Lighting Effects. A window will open with a circle surrounding your image.

3. Select Soft Omni from the Style pull-down menu.

4. Adjust the effect by grabbing the placeholder in the circle that appears and moving it in or out.

5. Adjust the ambience slider to your liking. This will increase or decrease the effect of the spotlight.

6. Click OK.

7. Save and close the image. (*NOTE: This effect works very nicely on black & white images.*)

Cropping and vignetting helped to improve the composition of this image. (Top: the original image, Bottom: the enhanced portrait.)

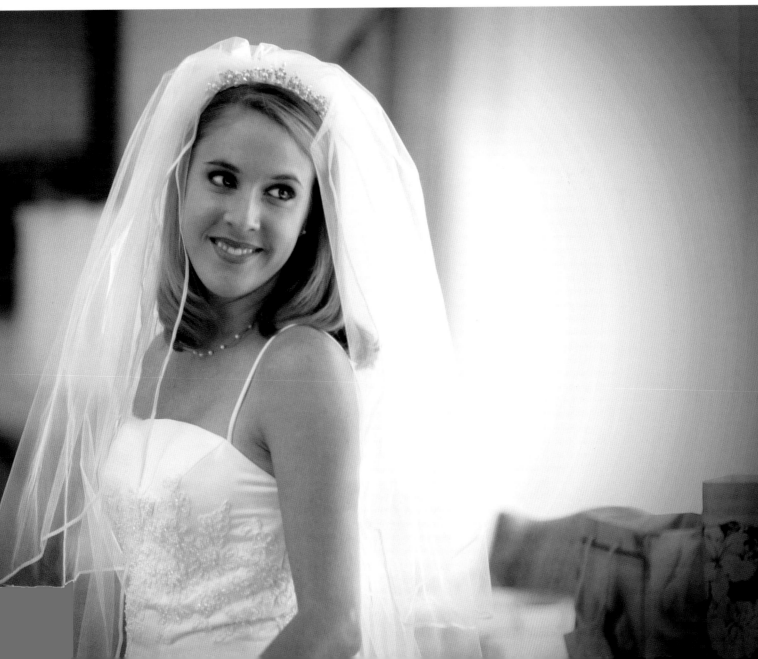

**Convert Images
to Watercolor**

1. In Photoshop, open an
image from the work folder.

2. Go to Filter>Artistic>
Watercolor.

3. Adjust the sliders as you like.

4. Click OK.

5. If you don't like the effect,
go to Edit>Undo. Repeat
step two, then enter differ-
ent settings in step three.

6. Save and close the image.
(NOTE: *Avoid using this tech-
nique on images with a lot of*

*detail. You can achieve better
watercolor effects in the ad-
vanced program Painter® by
Metacreations®. This program is
more complex, so begin with the
above steps and practice until you
become more comfortable.*)

Filters, like the watercolor filter
used here (top image), allow you
to add artistic effects to your
original photos (bottom image).

*Make Images Part
Black & White, Part Color*

1. In Photoshop, open an image from the work folder and copy the background to a new layer (see procedure on page 84).

2. With the new layer activated, follow steps 2–6 of "Convert Images to Black & White" (page 85).

3. Select magnifying glass and zoom in to a 200% enlarged view of the image.

4. Select the eraser tool and adjust the brush size as needed to allow for precise work in the desired area.

5. Using the eraser, remove the areas of the black & white image that you want to appear in color. This will allow the color image (in the background layer) to show through in the selected areas.

6. Control the intensity of the effect by adjusting the opacity of the eraser. Setting the eraser to less than 100% opacity will leave some of the black & white image in place, so the color image below it will show through less intensely.

7. Go to Layer>Flatten Image to merge the color and black & white image together.

8. Save and close the image. *(NOTE: You should always work at a 200% (or more) enlarged view when retouching. This will allow you to see more detail and ensure that your retouching is accurate!)*

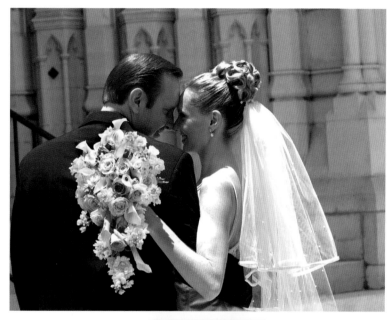

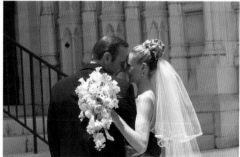

Resulting in something close to a classic hand-colored look, this technique is useful for emphasizing a subject by isolating it as the only colored element in the frame.

►TRACKING MODIFICATIONS

To make tracking these changes easy, we have instituted an image modification form system that allows us to track our workflow at this stage.

This form is placed on the photographer's or creative artist's desk at the time the client's work folder is prepared.

Typically, that is the Monday after the wedding day, but never later than Tuesday.

►THE NEXT STEP

At this point, the work folder preparation process is complete and the images are ready to be prepared for proofing. A selection of the images will be placed on-line, the videos will be creat-

ed, a proof portfolio will be made (if applicable), a work folder CD will be burned and the client will be called for viewing.

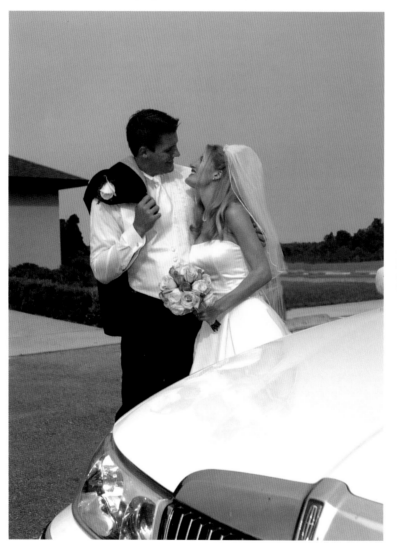

Digital retouching (here, used to correct a less-than-perfect sky and remove unwanted signs) can transform otherwise undesirable images into treasured favorites.

IMAGE MODIFICATION FORM

First names:_____ Last name: _____

Wedding date: _____

Wedding location: _____

IMAGE NUMBER	PHOTO MANIPULATION TECHNIQUE

STATUS TRACKING FORM

ACTIVITY	PERFORMED BY	DATE
Image modification		
Images On-Line		
Stock Photos Ordered		
Work Folder CD Burned		

STOCK PHOTO ORDER

VENDOR	IMAGE NUMER AND SIZE

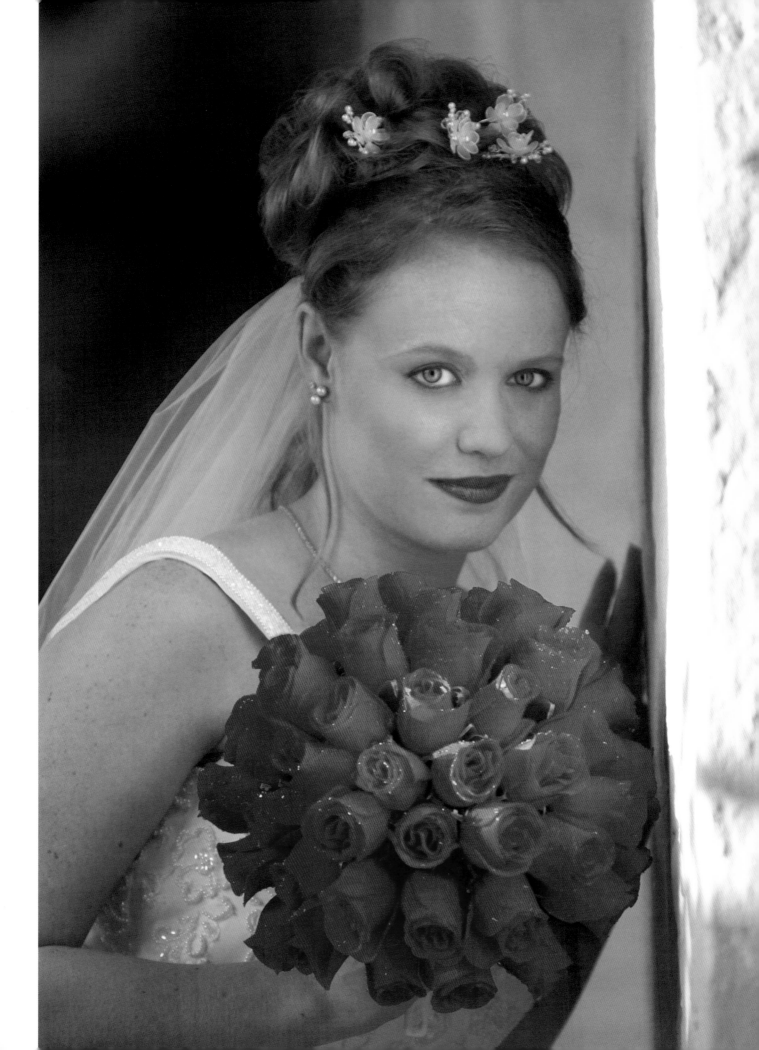

CHAPTER 10

DIGITAL PROOFING

A S MENTIONED IN CHAPTER 7, YOU SHOULD NOT begin referring to your studio as "proofless" when you make the switch to digital proofing. This implies that you provide fewer services than other studios. You do have proofs—state-of-the-art digital proofs.

This chapter will explore in detail how to create your proofing videos, place your images on-line, and use proof portfolios. (Keep in mind, previewing images on CD and DVD is in the near future. Until you are certain your audience will be able to view them with ease, however, your transition to proofing with new media should be slow.)

▶ CREATING THE PREVIEW VIDEO

Avoiding the paper proofing system can save you time and money. To begin creating a proofing video, open your work folder CD. From this, you can output your images to a slide show program such as EZ-Viewer® (visit www.gjcsoftware.com to locate the EZ-Viewer program), Montage® or Thumbs Plus®. We prefer EZ-Viewer because, for each image, the program displays a larger image number in the middle of the screen and you have the capability to change the font size and color of this number. The video should be created in a PC format using a video capture

This chapter will explore in detail how to create your proofing videos, place your images on-line, and use proof portfolios.

We recommend placing the bridal couple's videotape in a high-quality video cassette case (top, left), and the parents' copies in standard tape boxes (bottom, right).

card. The video card should possess a S-video or RCA-out connection. The S-video system is preferred and will give your images a higher resolution (more lines per inch than RCA); if finances are a concern, however, you can simply use a standard VCR with RCA. Next, connect an S-video cable into your VCR.

For multiple tapes, create a setup utilizing two or three decks (VCRs linked to one another). We prefer using VCRs from the same manufacturer. This way, you can use a single remote to activate all VCRs and begin recording simultaneously. This will support the dubbing of three videos at once.

Next, contact a local wholesale videotape supplier. (A videographer may be able to assist you in locating a contact person.) Purchase 120-minute tapes to create the copies. Make the copies at standard speed, as the noise will increase with slow speed tapes and lower the quality. Finally, employ a computer label program to professionally label your tapes. Include your company name, phone number and Web site on the video label.

These videos will be distributed (along with order forms) to each set of parents and the bridal party. Next, contact a local wholesale tape supplier.

We recommend placing the bridal couple's videotape in a high-quality video cassette case, and the parents' copies in standard tape boxes. Packaging is everything!

▶ ON-LINE ORDERING

Continue increasing your sales by instituting an on-line ordering program to expedite the flow of traffic onto your site and increase your outside orders. As mentioned in chapter 7, we promote a "20/20 View" on-line ordering program and display a minimum of twenty images on-line by the Wednesday after the couple's special day. Do not place *all* of the client's images on-line until *after* they have been in to design their album. Album sales are an emotional buy, and you want them to experience those emotions in your sales room—not in their living room.

For our on-line order program, we use the services of More Photos® (www.morephotos.com). They charge a flat monthly rate for the use of their services (rather than a percentage of sales, as some services do). That keeps us in better control of our images. More Photos creates a direct link to our Web site, so clients can simply go to our Web site, click the

on-line ordering icon, enter in their unique password and view their images. On the site, the client can add images to their shopping cart and purchase them right away. You determine the cost of the images, you maintain the quality and hold the copyright control. Additionally, all of the images are safely watermarked with your personal logo, so they cannot be downloaded in a useful form from the site. When a client places an order, you are conveniently notified via e-mail and can track your production in More Photos' Photo Manager® software. It has proven to be an easy, profitable and marketable system to implement.

Keep in mind, there are many other on-line ordering companies and options available—it is wise to research as many as possible to find the one that best suits your needs.

Adding a wedding listing to these services is typically quite streamlined. With More Photos, for example, we begin by opening their Photo Manager® software and confirming our pricing for the event. Next, we enter the event name and password. Then, after entering some basic information (such and the bride and groom's names, the location of the wedding, etc.), we simply select the images we

want to display and import them. The last step is to check the Web site itself and make sure that the display is correct.

► DIGITAL PORTFOLIO

Another form of proofing is the portfolio proofing method. We use this in conjunction with the videos for our high-end clients. We also use it as a booking incentive to upgrade to a higher level. To build a digital portfolio, you can use Photoshop, Thumbs Plus or EZ-Viewer to create a contact sheet. When creating a contact sheet, it is best to convert all the images to

black & white so that color management will not be needed. Place approximately nine images on each page. This proof is to be used in conjunction with the video proofing, so the images can be quite small. Print your contact sheets using the laser printer (this is faster and cheaper than an inkjet).

Finally, bind the contact sheets (we use the Art Leather Digital Portfolio). Make sure your company name is on the front of the portfolio, and place your contact sheets, order form and other required paperwork inside.

Working with black & white thumbnails (to eliminate the need for color management), a digital portfolio can be created using digital contact sheets generated by your laser printer.

ALBUM DESIGN

PROFICIENTLY COMPLETING THE CYCLE WILL HELP YOU make the most of the time and money you invest in the transition to digital methods. Every bridal couple is an investment. You also invest in advertising and other applicable expenses, but most of all, you invest yourself and your time. Making the most of your dollar is very worthwhile. This task can be accomplished by dynamic album design techniques. These procedures involve, but are not limited to, scheduling the album design, designing the album and closing the upgraded sale.

A productive album design system can increase your profits, encourage double album sets, and expedite the album completion time. Once the proofing system is in place, you should be ready to conduct your album design by the time the client returns from their honeymoon. When they return they will get excited when they check their messages and hear your voice asking them to contact you to schedule an appointment to design their album! We also recommend sending them an e-mail notification with a link to your site and a sneak peak at the "20/20 Vision" images.

▶ PREPARING THE CLIENT

Local Clients. Once the videos are complete, we contact the

Making the most of your dollar is very worthwhile. This task can be accomplished by dynamic album design techniques.

couple to schedule their album design. Ideally, this process is complete within one week from the date of their wedding. When we schedule their album design time, we explain it as follows:

STUDIO REPRESENTATIVE:
"Hello, Suzy! How is married life? Did you have a great honeymoon?"

CLIENT:
(Her response)

STUDIO REPRESENTATIVE:
"Fabulous! Well, I know you are excited to see the fantastic images, so let's schedule a time to get together as soon as possible. This is how the process works. First, you and your husband will need to allocate about three to four hours. The earlier the better! What we will do is have you first view your video privately in our home theater room. Watching it on our system will give you a clearer, higher quality image. *(Listen to her verbal feedback.)*

"Jeff will have predesigned what he would call the 'Perfect Studio Album.' Because you have probably never designed an album before, he will help you create the format and develop a true storybook rather than a scrapbook. You will then go through image by image, page

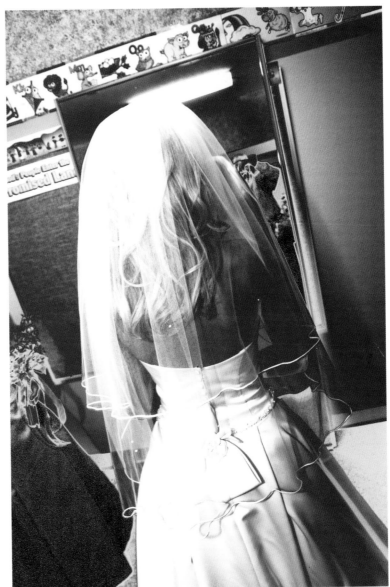

Once you've worked hard to wonderful images for your clients, you can help get them excited (and ready to buy) by enthusiastically presenting the benefits of your album design procedures to each client.

by page and personalize it to create the ideal wedding album for you. Technology is great! With a click of a button, you can change the mats and move the images. You will see what your album looks like before it goes to production! *(Get verbal feedback.)*

"The time you spend will vary depending upon how many changes you make. Some couples can have their album completely designed in two hours.

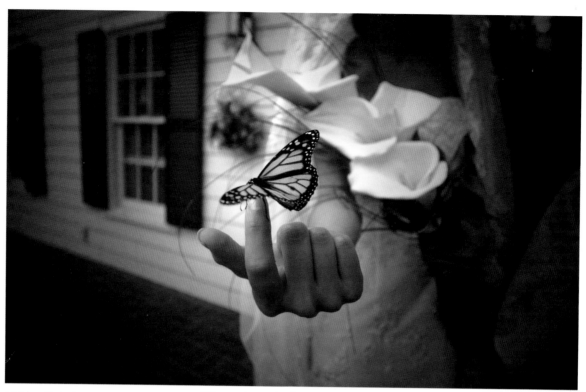

With digital imaging, you can present priceless images like these in days instead of months.

(Keep in mind, it will take approximately an hour for you to preview your video.) Some couples take a little longer. We request that you allocate three or four hours, just in case. If you have to leave, when you return it will take additional time to get back on track. This way, when you leave our studio, you will leave with a completed design for your album and a printout of what it entails. You will also leave with three duplicate preview videos (one for you and one for each of your parents) and additional order forms.

"In the following few days, your order will be pulled and sent to the lab. You should have a finished album in about six weeks. This typically is only two months from your wedding date! *(Get verbal feedback.)*

"So, what would be best for you—morning, afternoon or evening?"

CLIENT:
(Her response)

STUDIO REPRESENTATIVE:
"The beginning of the week or the end of the week?"

CLIENT:
"The weekends would be best."

STUDIO REPRESENTATIVE:
"Well, as you know, Saturdays are very busy for us and Sundays are reserved for weddings only,

so if it has to be a weekend our next morning opening isn't until (month/day). I would hate for you to wait that long to view your images. Is there any way you and your husband could leave work a little early on a Friday afternoon?"

CLIENT:
"The evening is best, beginning of the week."

STUDIO REPRESENTATIVE:
"Great! What is the earliest time you can be here? How about Monday, the 14th at 5:30 p.m.?"

CLIENT:
"The evening is best, but we can't be there until 7:00 p.m."

STUDIO REPRESENTATIVE:
"We need to make it a little earlier. The latest we will schedule album designs is 6:00 p.m. We have found that the later you go, the more tired you get—and then you just can't design a quality album. After all, you want to be at your best. This is a family heirloom that will be passed down for generations. Is there any way you can talk to your husband and see if you can adjust your schedules to be here by 6:00 p.m.?"

CLIENT:
"Can't we just take the videos home to review them and decide what images we want before we design the album?"

A couple's wedding album is an heirloom their family will treasure. If you emphasize this, it will be easier to show your clients why quality is important.

STUDIO REPRESENTATIVE:

"I'm sorry, but that's just not our policy. I cannot let the videos leave the studio until your album design has begun. We have found, in past situations, that once they leave the studio it delays the design and interferes with established systems." *(Never let the videos leave the studio until the album design has begun. If you are stern about your policy and do not make exceptions, your client will accept it. The day the client first views the video the images possess their highest emotional value. Thus, they are willing to spend more. If you allow the videos to leave the studio, the clients take them home, overanalyze them and narrow their choice down to a select few images. They are no longer emotionally attached; they now become overly critical and extremely practical about their decisions. Something as important as documentation of their special day should be an emotional buy, not a practical one.)*

Out-of-Town Clients. When the videos are almost complete, we contact the couple to begin the album design process. This process is ideally completed two weeks from the date of their wedding. For out-of-town clients, extra time is required because we have to send the couples' three preview videos, a letter with instructions to follow and a sample album design. All of our out-of-town couples (those over two hours away) automatically receive all of their images on the on-line ordering to make image selection and design easier.

When we submit their album design package, we call first and explain it as follows:

STUDIO REPRESENTATIVE:

"Hello, Suzy! I hope married life finds you well! How was your honeymoon?"

CLIENT:

(Her response.)

STUDIO REPRESENTATIVE:

"Great! Well, I know you are excited to view these incredible images. I'm sure you will be very pleased. This is what we are going to do.

"First, I will be mailing you a package with three duplicate preview video tapes. One is for you and the others are for your parents and your husband's parents. Feel free to duplicate them as many times as you wish and send them all over the world, if you like.

"Next, we will also be sending you a sample album design. Jeff has designed what he would consider the 'Perfect Studio

Album.' What you need to do is sit back and watch the video in private. Do not go through and pick out the images you want. It is too difficult that way, and you probably will not get a complete storyline. However, do go through and jot the numbers of the images you never want to see again! Once you have made your list of the images you do not want to see again, give Jeff a call. At that time, you can walk through your album design and create a perfect storybook of your special day."

CLIENT:

(Her response.)

STUDIO REPRESENTATIVE:

"Great! I am going to put it in the mail today. Give us a call at 1-555-555-0000 to discuss it further and get your design processed. Remember, do not delay—we are very busy and a delay would mean that we would have to reschedule the production of your album. That

could delay your final product by months."

► THE ACTUAL DESIGN
Once the preview tape has been reviewed, the album design can begin. To begin this process, first discuss the color, type and style album the client prefers. Counsel your client about color harmony. Black is wonderful, because it showcases the images without clashing with the colors of the church, dresses, flowers, etc. When selecting additions like gold or silver writing/ page-tips, consider the images. If there is a lot of gold in the church, for example, gold trim may be best.

Black & White with Color. Also, use caution when combining black & white with color images. These should never mix on the same page. Showcasing the two styles on facing pages is acceptable, but should not be done excessively.

Image Size. Remember, when designing a Montage® layout, the size of the images will be established by the digital images themselves. Primarily 3"x5"s, 4"x5"s and 5"x7"s will be used to design the storybook album. Reserve the 8"x10"s and the 10"x10"s for posed groupings, or for momentous events like the cake shots, the first dance, or the toast.

Action and Reaction. Additionally, each action should have a reaction. For instance, you might pair two photos so the daughter dancing with Dad is next to one of Mom crying.

Bookending. The successful storytelling album designer also leads the viewer where he wants them to go by using the

Even strong black & white images can lose some of their impact when placed next to color photos. Because of this, color and black & white should not be mixed on the same page, and should be used carefully when they fall on facing pages.

▶ USING MONTAGE PRO®

To begin using the Montage Pro album design program, order the program from Art Leather by calling (888)252-5286 or by visiting their Web site. Next, using the Montage Pro user's guide, optimize your display settings and install the software. As indicated in the Montage Pro user's guide, when creating your first album, begin by following these three main steps. First, create a client folder. Next, create an album for the client. Finally, place the selected images into the desired album.

To create a client folder follow these steps:

1. Open Montage Pro.
2. In the "select client" screen, click the "add new client" button.
3. Enter in the clients' first and last names and address into the desired fields. When naming the client, use any combination of letters and numbers but do not use slashes or hyphens.
4. Save the client information.

Create an album for the client by following these steps:

1. Click the "add new album" button.
2. In the "create new album" screen, type in the clients' names and select "new album." Click OK.
3. Now, you should see the album definition screen. This screen is divided into four sections: album definition, cover definition, album text and inserts/mats.
 (NOTE: *You must complete each section in order to continue.*)
4. In section one, the album definition section, highlight the type of album you would like and then select the size and binding options you desire.
5. In section two, the cover definition section, select the material color, the cover design and assembly option for the album. You will then be able to see a preview of your album in the window to the right of this section.
6. In section three, the album text section, select the spine title, cover title and imprint option for your album. Be sure to check your spelling for accuracy!

7. In section four, the insert/mat section, select the mat and mylar color for your album.
8. When you are satisfied with your selections, hit OK.

Lastly, design the album. To do this you must first import the digital images.

1. From the file menu, choose "select images for client" or under the contact sheet tab, click the "select image" folder.
2. Select the file that contains the images you want to use for this client. Only one image folder can be opened per client. If you have images for the same album saved in different folders, move them all into one folder before opening in Montage Pro.

Once the image folder is open, move the images into the preferred mats. To create your images and mats follow these steps:

1. Click the "mat design" tab.
2. Click the "add mat" button.
3. Select the type of mat you wish to use. Use the Art Leather catalog as a guideline until you become more familiar with your preferred mats.
4. To put an image into the mat, simply drag and drop the thumbnail of the image into the desired mat opening. The thumbnails are located at the bottom of the screen.
5. To change a mat, simply use the "select mat" tool.
6. To rotate a mat, use the "rotate mat" button, highlight the mat and click the button to the desired rotation.

To tell the story of the day, the album should feature paired images of actions (the bride walking down the aisle) and reactions (the groom smiling from the altar as she approaches).

bookend concept. This means making sure that each image looks into the page (like bookends). This design principle leads the viewer's eye into the center of the pictures, not out.

Continuity. Arrange the images with continuity. Lead the viewer where you want him to go, using setup shots (the cake, church and room setups, etc.) to take the viewer into the next event. For example, to document the couple arriving at the reception, open with a shot of the room setup. This is is a visual cue to the viewer that something (in this case, the location) is about to change.

▶ TRIAL CLOSES

Throughout the album design process, remind the clients of the importance of a unique sto-

rytelling book. As you design it, make suggestions on proper images and ask trial close questions. Always ask a minimum of five trial questions per design. These questions can include:

• Are you beginning to see the importance of using these detailed images to tell the story of your day?

• How do you like it so far?

• Isn't this wonderful? Wow, it looks incredible!

• Isn't this exciting, seeing the story unfold?

• Aren't you excited about showing your storybook to someone who couldn't be there with you and having them relive your day?

• Do you see how this all fits together?

• Don't you just love that series of images?

Educate them on the storytelling process throughout the design process. Each time they answer "Yes!" to one of your trial-close questions, they are closing the deal themselves. If they object to the album upon completion, you will know it is strictly a financial objection.

Tell them in the beginning, the middle, and the end of the design process, "We want you to have the perfect album. It is a family heirloom and will be with you for a lifetime. We want it to be exactly the way you want it. I am here to help you any way I can. Let's just focus on making

this album perfect for both of you."

Once you have designed a perfect album, suggest that the couple separate their formal section from their storybook. All they have to pay for is an additional cover. This way, their viewers do not get a workout when looking at their album. Our standard storybook album consists of 36 inserts (or 72 sides). The formal book typically ranges from 12 to 18 inserts.

▶ PRICE

Do not go over price with your client halfway through the design, because then they will scale back—making financial decisions rather than emotional ones.

If they ask you, "How much does this cost?" Your response should be as follows: "I have no idea what this is going to cost. Each album varies greatly. Let's just walk through and finish it perfectly. Then we can go back through and tweak it as needed. Just keep in mind, if you eliminate one page you have to eliminate two. In order to make a big dent to lower the cost of the album you will have to cut out a lot of images, thereby getting rid of the storytelling concept."

You might also want to mention again that, "We want

you to have the perfect album. It is a family heirloom and will be with you for a lifetime. We want it to be exactly the way you want it. I am here to help you any way I can. Let's just focus on making this perfect."

Once the album is completely designed, ask them another trial close such as: "So what do you think? Don't you just love it?"

Then click over to the invoice summary page. Show the total amount of pages and prints. Indicate and deduct their credit. Then, show the balance due. They will be sticker shocked! Typically, the balance will be $1000 to $3000 over the couple's initial investment. Respond as follows: "Don't worry! We can break it into two or three payments—whatever is easier for you."

Don't tell them you can go back through and redesign it. They already told you they loved it just the way it is. If they make changes, it is all about money! If they are still hesitant after the two or three payment option, respond as follows: "I know you love the album exactly the way it is. Instead of going back through and ripping it apart and taking out all of those images that you just told me you liked, let me see what I can do."

After pausing to review the figures, continue with: "If you accept the album just like it is, I will deduct $3.00 for the 3"x5" and the 4"x5" price. (Subtract $3, $4, or $5 from each of the images.) That will lower the cost from $15.00 to $12.00 each and save you $300.00. How does that sound to you? Whatever you prefer is perfectly fine with me." We typically make the deduction from the 3"x5"s, or 4"x5"s because this is where most of the money is spent in the typical album. These are also the first images clients tend to delete. Once you make that subtraction, they usually go with it. Those that do not are the exception, not the rule.

In closing, the main components of an album design consist of preparing the client to leave with results, building a sellable story line, and closing them on the importance of the product while overcoming objections on price. Remember: if you believe it, you can achieve it! Don't undersell or underestimate the value of your work. Once the design is complete, print out the order and place it into production.

CHAPTER 12

ALBUM PRODUCTION AND ASSEMBLY

Wmb ITH CURRENT TECHNOLOGY, YOU CAN VERY easily send an album order to the lab ten days after the client's wedding. Such advancements have tremendously expedited our workflow. Our clients are pleased and their friends are amazed. As you begin to take

full advantage of this expedited workflow, however, there are some additional steps that are critical to your success.

The preparation process actually begins in chapter 7. However, the final steps are crucial. These can be divided into two categories: the lab relationship and monitor calibration.

▶ LAB RELATIONSHIP

Begin by contacting the lab of your choice. Ask to speak with a digital developing contact (the customer service department cannot help you with this

process). You need to establish a strong relationship with the person retrieving and printing your files. They need to understand your style and you need to be able to contact them when you are experiencing problems. If the lab will not allow you to speak with anyone directly, consider searching for another, more personalized lab.

▶ MONITOR CALIBRATION

Next, ask your lab to send you a test file—preferably one you can download—along with a test

The final steps can be divided into two categories: the lab relationship and the monitor calibration.

print. You will use this test print to match the color of *your* monitor (displaying the test file) as closely as possible to *their* monitor. After matching it up, send them a file of your own to print and evaluate whether it matches correctly. If it does not match, you will need to take additional steps to calibrate your monitor. The following steps will address this procedure. Don't let the calibration process frustrate you. This is one of the most difficult and crucial steps to traveling down the digital path. If you try the following suggestions and are still experiencing conflicts, then consider hiring someone to come in and calibrate your monitor for you.

When you place a digital image onto a computer screen, a numerical value should be assigned by the computer to each pixel (red, green, blue). If these values are not defined, then there is no standard by which the image can be viewed in the same way from computer to computer. The control system used to identify the numerical value of colors is called color management. This creates workflow consistency.

Most monitors are calibrated to produce accurate colors. There is basic monitor calibration software that can help you achieve this, such as Adobe®

Gamma® (which is automatically installed with Photoshop) or Colorimeter®. Adobe Gamma is a great starting tool, providing a simple, inexpensive tool for calibration. The Colorimeter is a high-end calibrator that uses a suction device (which sticks on the monitor) to read the range of colors displayed on the screen.

Basic Monitor Calibration using Adobe Gamma

1. Determine what type of monitor you have.

2. Next, click "start" then "settings" then "control panel" and "Adobe Gamma."

3. Select the step-by-step program, hit "next."

4. Identify the monitor you are using.

5. Move the contrast control on your monitor to the highest setting.

6. Adjust the brightness control on your monitor to make the center box as dark as possible (but not black) while keeping the frame bright white.

7. Define your phosphors. A phosphor is a luminescent

substance in cathode-ray tubes that emits light when excited by electrons. In regard to photography, phosphors play a roll in how the tubes in your monitor create the visible color on your screen. Check your monitor's manual to determine what type of phosphors are in your monitor. For example: HDTV, P22-EBU, SMPTE-C, Trinitron, or custom. If you can't find this information, select the SMPTE option.

8. Click "view single gamma only," then move the slider back and forth until the gray center box fades into the patterned frame. Uncheck view single gamma only.

9. Next, you will see three boxes: one red, one blue and one green. Eventually, you can adjust each color as needed from this screen, but that is more complex and is not necessary for basic calibration.

10. Go to the gamma window. Here, the Macintosh default setting is 1.8 and the Windows default setting is 2.2. Again, avoid using custom settings for now as these may not be needed.

11. Select the white point for your hardware. If you know it already, enter it (a good staring point is often 6500°K). If you do not, hit "measure." Be sure to eliminate all ambient light from the room while doing this—and seek someone else's opinion. Your eyes can easily play tricks on you.

12. Press OK and your screen will go black with three white squares. Choose the most neutral gray square (by clicking on the left and right squares, you will make the square cooler or warmer). Click the center square to finalize your selection.

13. Press ESC to cancel and return to the main screen. For now, keep your white point set to the same as your hardware.

14. View before and after.

15. When you are satisfied, click "finished" to accept your changes.

16. Type in a name for your profile and save it. You may want to label the profile with the date (such as "monitor 2/18/02"). This

will remind you of your last calibration and keep you aware of update needs.

▶ **FILE PREP SYSTEM**

Once you are comfortable with your relationship with your lab and monitor calibration, you can initiate the image ordering process by applying the file prep system and retouching process. This process can be instituted by using the following systems and procedures:

Organization. To begin with, highlight the different image sizes on your client's order form. For instance, highlight the 3"x5"s in pink, the 5"x7"s in green and the 8"x10"s in blue. This system will make cropping easier and more efficient. Next, begin the following steps:

1. Create a folder named "file prep" under the client's name.

2. In the file prep folder, create subfolders for each image size.

By carefully organizing your digital images, you can make the retouching and album design processes much easier.

3. Open the client's CD with the original copies of the images. Select all of the 3"x5"s and copy them into the 3"x5" subfolder. Repeat for each image size.

4. After filling all of the subfolders with the ordered images, open each folder in Photoshop, then crop and color correct.

Cropping. When using photo manipulation software, it is important to remember that there are many different ways to accomplish similar results. You should use whatever techniques you feel most comfortable with.

1. Open an image in the 3"x5" file prep subfolder.

Crop marks showing on an image in Photoshop.

2. Select the crop tool.

3. In tool options (at the top of the screen near the menu bar), select the desired image dimensions (in this case, 3"x5").

4. Set the resolution as recommended by your lab.

5. Adjust the anchors of the cropping tool over the image.

6. Click OK and save.

Color Correction. The most important step in color correction is *practice*. The two most commonly used tools for color correction are levels and curves. Levels is typically easier to learn and is a good beginning

tool. However, the curves tool offers more control, meaning you can achieve better contrast and more accurate skin tones. Remember, when using either of these tools, less is often more!

To open the levels tool, go to Image>Adjust>Levels. You will see there are two different levels: the input level (three boxes at the top controlled by three sliders at the bottom of the histogram directly below) and the output level (two boxes at the bottom controlled by two sliders at the bottom of the grayscale directly below). The input levels adjust the distribution of pixels in the image, while the output levels adjust the black and white point.

The histogram (the jagged black diagram in the input levels

The levels dialogue box contains a histogram (a graphic representation of the tones in the image) and sliders used to adjust the tones.

box) is a representation of the tones in the image, ranging from the black point and shadows on the left, to the highlights and white point on the right. In an image with a good range of tones, the histogram will fill the length of the chart (i.e., it will have dark shadows, bright highlights and everything in between). Furthermore, in a good portrait the pixel density (in the output levels) should be close to zero on the left (or shadow) side and about 250 on the right (or highlight) side.

Using Levels

1. Open an image in the 3"x5" file prep subfolder.

2. Go to Image>Adjust>Levels.

3. In the output levels, move the slider on the left to adjust the shadow to your liking. This usually looks nice at about 5.

4. In the output levels, move the slider on the right to adjust the highlight to your liking. It usually looks good at about 250.

5. After adjusting the sliders above, turn to the input levels. If the image is too dark, move the center slider (under the histogram) to

the left. If the image is too light, move it to the right. This center slider represents the midtones in the image.

As noted above, using the curves tool is more complicated and requires more practice. However, skilled users find it the tool of choice for making precise color correction.

When you open the curves dialogue box, you'll see a grid with a diagonal line running from the bottom left to the top right. This line represents the tones in the image, with the bottom left point being the darkest shadow and the top

right point being the brightest highlight. By clicking on this line, you can add handles and drag the line up or down. By adding multiple handles, you can drag the line into an S-curve. For natural-looking results, keep bends in the line as small and smooth as possible.

In the process below, you will also use the black point, gray point and white point eyedroppers. These are located near the bottom right corner of the dialogue box. As their names suggest, they are used to manually select the black, gray and white points in an image.

The curves dialogue box features a diagonal line that can be bent to alter the tones in the image.

Using Curves

1. Open an image in the 3"x5" file prep subfolder.

2. Go to Image>Adjust>Curves.

3. Click on the center of the diagonal line and move it up (lighten) or down (darken).

4. Select the black point eye-dropper, then click on the darkest point in the image.

5. Select the white point eye-dropper, then click on the lightest point in the image.

6. Select the gray point eye-dropper, then click on an average midtone in the image.

7. Adjust to your liking and continue to practice this technique until you are comfortable with it.

The final step in the file prep process is to use Photoshop's color balance tool. This will finalize the color correction and prep your image for printing.

Using Color Balance

1. Open an image in the 3"x5" file prep subfolder.

2. Go to Image>Adjust>Color Balance.

The brightness/contrast tool can also be very useful. To use it, go to Image>Adjust>Brightness/Contrast. Then, adjust the sliders as you like. This tool should be used with great caution, however, since it does not offer very precise control. If used to excess, it can easily destroy detail in the highlight and shadow areas.

In the color balance dialogue box, sliders are used to adjust the overall color in an image.

3. You will see three different sliders: cyan/red, magenta/green and yellow/blue. Adjust as needed to achieve a pleasing color balance.

4. Once it is to your liking, hit OK and save.

Retouching Process. The next phase of the file prep process is retouching. The two basic tools we would recommend for beginners to start the retouching process are the lasso tool and the clone tool.

The lasso tool allows you to make a selection in order to remove an object. For example, imagine you have a photograph with a light switch showing that you want to conceal.

Using the Lasso Tool

1. Open the image.

2. Identify another area in the photograph where the image data could be used to cover the problem area (for example, an area of the wall next to the light switch you want to cover). The selected area should have the same lighting condition as the area being covered. This will reduce the need for blending.

 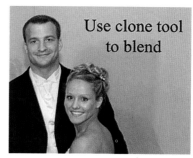

The lasso tool can be combined with the clone tool to conceal distractions in an image.

3. Select the lasso tool and trace a line around the area to be used to conceal the problem.

4. Copy the selected area (Edit>Copy) and paste it onto a new layer (Edit>Paste).

5. In the layers palette, activate the new layer containing the "patch" and move the copied material into position over the area to be concealed.

6. If needed, use the clone tool to blend the edges (see below for instructions).

7. Flatten the image (Layer>Flatten Image) and save.

The clone tool is used to blend out an area—to remove a blemish, for instance. It is often referred to as the rubber stamp tool (this was actually its name in earlier versions of Photo-shop). Cloning is essentially the process of painting one portion of an image onto another image (or another part of the image). For best results, begin with a low opacity setting on your brush (adjust the opacity in the tool options palette at the top of the screen) and build up to a higher opacity. This tool should be used carefully and sparingly. Improper or excessive use can make your image look very retouched! Again, practice is critical to success.

Using the Clone Tool
1. Open the image.

2. Select clone tool.

Clone-tool pull-down menu from the Photoshop toolbar

3. In the options palette, set the clone tool opacity to 25% (or to your preference).

4. To select an area to clone, move your cursor over the area, hold down the Alt/Opt key and click. This blending area should match the tone and texture of the area to be retouched and be as close as possible to it.

5. Click on the area to be retouched.

6. Repeat steps four and five until the problem is corrected and looks natural. If necessary, hit edit undo to immediately reverse any change that looks bad (or undo multiple steps using the history palette).

7. Save the image.

Keep in mind, these tools represent only two of the most basic options for retouching your photos. Begin with these to eliminate flaws and remove imperfections. However, keep your options open and continue to learn! There is a world of possibility at your fingertips, and practice makes perfect.

Once your images have all been retouched and color corrected, consult with your lab to determine their image specifications. The following typical procedures may be helpful.

Rotate to Vertical. Our lab requires that all of our images are rotated vertically. This may be different for you. If they do need to be vertical files, follow these simple steps:

1. Open a horizontal image.

2. Go to Image>Rotate Canvas.

3. Rotate 90° counterclockwise (CCW) to a vertical orientation.

Change File Format. Our lab also requires files to be saved in the TIF file format to achieve the best results. To save an image in the TIF file format, follow these simple steps:

1. Open an image.

2. Go to File>Save As.

3. In the format menu, locate TIF and select.

4. Hit Save. You will then see a TIF option window. It will ask you to save in a PC or Mac format. Select the option preferred by your lab, not based on your own computer. Do not use the LZW compression option.

Burn a CD. Complete the preparations by burning a CD and sending it to your lab. One of the incredible benefits of going digital is that when your prints return, they will most likely already be numbered. All you need to do is cut and secure them in your album for delivery.

Remember, with the awesome advancements in technology, you can very easily send an album order to the lab ten days after the client's wedding. To test this, we had an assistant complete a roll of film while playing with her 35mm camera during a wedding. The film was taken to a local lab for processing. The digital proofs were prepared, the album designed and the order processed before the negatives were even *developed!* This is a time-saver you cannot afford to skip.

► HINTS AND TIPS

If you elect to print your images in-house, use a high-grade paper. The type of paper you select will affect the quality of the image. Read your printer manual and understand your options before beginning.

CHAPTER 13

ASK THE EXPERTS

N THIS SECTION, YOU'LL LEARN HOW OTHER INDUSTRY professionals are making their way in the digital world—and hear their advice to others embarking on the digital transition.

▶ BILL HURTER

Bill started out in photography in 1972 in Washington, DC, where he was a news photographer. He even covered the political scene—including the Water- *gate hearings. After graduating with a BA in literature from American University in 1972, he completed training at the Brooks Institute of Photography in 1975. Going on to work at Petersen's PhotoGraphic magazine, he held practically every job except art director. He has been the owner of his own creative agency, shot stock and worked assignments (including a year or so with the L.A. Dodgers). He has been directly involved in photography for the last twenty-eight years and has seen the revolution in technology. In 1988, Bill was awarded an honorary Masters of* *Science degree from Brooks Institute. He has been the editor of* Rangefinder *for the last five years.*

On the Transition. "The digital transition occurred for us because of the sweeping changes in the publishing and prepress industries. The cost savings of converting to digital images were large and immediate. Now, literally everything we do is digital. We still get a number of articles with conventional images, but everything is scanned for publication. *Rangefinder,* in addition to

being "direct to plate" (filmless) is now one of the first magazines in the country to proof online, with no blue line. The advances in technology have grown so quickly, that we now proof a version of the magazine that is automatically generated by uploading it to the printer's FTP site, so that we are effectively proofing the final version before the printer ever touches the issue."

Talented Tips. Bill's advice is to "be open to all sorts of influences. I have seen technology influence style and style influence technology, but the biggest advance I have seen for wedding photographers in the last several years is the advent of the digital album. The digital album brings into play the photographer's graphic and story-telling skills much more than a conventional album. Digital albums are quite popular and are helping to expand the wedding photographer's business by leaps and bounds. I am also seeing an influx of styles because of the resulting ability to review other photographers' work on-line. At the recent WPPI (Wedding and Portrait Photographer's International) convention, the album competition looked like a melting pot of styles, with influences from Australia, England, Japan and Europe being evident in the styles of these primarily American photographers. It's really remarkable."

▶ CURT LITTLECOTT

Curt owns Nu Visions in Photography in Orlando, a seven-year-old wedding photography studio with a full-time staff of four. The studio has a reputation for its documentary-style wedding coverage, with black & white used 70% of the time. All finished album prints have been printed in-house digitally for the past three years, allowing full creative control. During Curt's first year entering print competitions (in 1999) he received first and third place at the WPPI convention with scores of 95 and 96—as well as a PPA loan collection award. At the most recent FPP convention, he claimed first, second, and third place in the Social Function/Candid category. For the past two years, Curt has been a speaker at the WPPI conventions in Las Vegas, sharing his ideas on photojournalism and digital imaging as it relates to weddings.

Transition. "Above everything else, wedding photography has to be fun! Having no formal training was a blessing in disguise for me. For the first couple of years in business, I felt that, because I lacked the training to be able to correctly light and pose, I would just have fun shooting candids and telling stories through my pictures. For this I charged about half of the amount the local 'real' photographers were charging. Brides would look at my albums (glorified scrapbooks) and remark that my work was different than they had seen. I took "different" to mean "not so good"—but, heck, I was cheaper!

"Being the cheapest guy in town is no picnic! Pretty soon, I was shooting more than one wedding a day. The brides were becoming more demanding—they had lists, annoying moms,

long trains, huge bouquets and lots of relatives all wanting their pictures made! When it ceases to be fun, I believe everything suffers, but perhaps most of all creativity. It became a job—a crap job!

"Out of the blue, a photographer called to see if he could meet with me to see some of the 'photojournalistic' photography I was doing. I thought I was busted! This guy, the owner of a successful local studio, had apparently been asked by brides if he took pictures like mine. Although he didn't seem to like the art-supply-store albums I used, he was very complimentary about my work and said it was 'Dennis Reggie' style. I wholeheartedly agreed and set out to find out who this Reggie guy was! I was on to something.

"Well it turned out that there were organized groups of wedding photographers out there sharing ideas, entering competitions and holding seminars. I felt like a soldier found in the jungle who didn't know the war had been over for forty years! That month I joined WPPI, PPA, FPP, PPSCF and ASMP.

"Soon, I had a purpose and even some knowledge. I attended a Dennis Reggie seminar and my world was rocked! I realized that, if I refined my work and the presentation of it, I could actually charge *more* than "real" photographers. I focused on presentation of product and immersed myself in photography books and magazines. There, I discovered the digital world!

"Now I can capture and print the things I see in my mind's eye. My renewed enthusiasm has been rewarded with customers happy to part with far more money than I would ever pay for wedding photos!"

Talented Tip. "Go mostly digital. For the past two years I have been using digital cameras for about 60% of my wedding coverage. Digital cameras have some wonderful advantages that we are familiar with. Don't get caught up in the hype—but do use *all* the tools available; you owe it to your customers. Become very familiar with Photoshop, then let your imagination and creativity run wild!"

▶ STEWART AND SUSAN POWERS

Stewart started as a photographer in high school on the annual staff. He continued in college as a photojournalist-type photographer, then went to art school at the University of Florida. He earned a BFA in 1977. He went back to school in 1982 and earned an MFA in photography in 1985. At that time, Stewart was working full time in a camera shop and photographing weddings on the weekends with his wife Susan. Susan grew the business until Stewart went to work for her full-time. They joined the FPP (Florida Professional Photographers) in 1985 and began to learn about "professional photography." Their wedding album style has been very successful with clients and in competition. They have also won three Kodak Gallery Elite Awards, eight PPA Loan Albums, three first-place awards in WPPI album competitions, and numerous other accolades. The

Powers operate a residential gallery in Gainesville, Florida, specializing in weddings and environmental portraiture.

Transition. Stewart and Susan have "mucked about" with digital imaging since the first 1-megapixel cameras came out. Their first semi-serious camera was a Canon D30 SLR, which they got as soon as it was on the market. They have been integrating it into their wedding work and children's portraiture business ever since.

Stewart indicates that there are still some challenges, however. "I still have problems with the APS-size viewfinder and the 1.5 lens magnification is irritating. I am comfortable and fast with a medium format SLR, and it is taking me a long time to achieve that level of expertise with a digital camera." Presently, they capture a lot of candid images and convert many of them to black & white.

Stewart loves the many advantages of digital capture, but still uses a lot of medium format film at weddings. He expects to complete the transition in 2002, but is a cautious fellow, and takes small steps to ensure he is satisfied with his results. "I feel we have a standard that we would like to maintain—no matter the capture method."

His goals include wanting to increase the types and variety of image products they offer, and to speed up the turnaround time for delivering photographs to their clients. Though he does not view digital imaging primarily as a chance to save money on film, he does see it as having great potential to excite new clients and thrill old ones.

Talented Tips. The Powers also prefer to avoid the use of the term "digital." They comment, "It still has as many negative connotations as it has positive ones with our clients." Instead, they like the term "creative capture." Unless asked, they do not discuss with clients how they capture the images.

Stewart also advises purchasing a FireWire, portable, battery-powered, 6–10G hard drive, then copying your digital image files over to it whenever you have a break at the wedding. By the end of the day, this means you have a complete duplicate set of the image files on the disc without removing the CompactFlash card from the camera. However, not all cameras support FireWire, and many portable hard drives are only USB (which is much slower). Stewart looks forward to better fast, convenient and reliable backup solutions. He is sure they are on the immediate horizon—he just has not seen the right one yet.

Says Stewart, "The most exciting aspect of film to digital or just direct digital is the incredible power of Photoshop to improve all aspects of the imaging process. On a personal level, I am fascinated by the ability to give clients all their wedding day images in a custom Web gallery on a CD (a technique I learned from photographer Zeke Cejas in Miami, Florida). They look great, are in chronological order, and have a bundle of advantages for the client. I will be interested to see if my clients are as attracted as I am to this new method of viewing their wedding images. Time will tell."

▶ BARBARA AND PATRICK RICE

Barbara and Patrick Rice have been involved in the photography business for over twenty years. Each has received the PPA Masters, Craftsmen and Certification degrees, as well as all levels of the WPPI Accolade (Masters) program. Their busi- *ness specializes in weddings and portraiture.*

Transition. Barbara & Patrick began to make the transition to digital three years ago, with the purchase of a Kodak 290 digital camera. They then purchased a Nikon Coolpix 950 and most recently a Canon D30. "The ability to see that we have the shot immediately after it is captured is the most exciting aspect of the digital transition. We no longer have to wait days for the film to come back from the lab to show the clients their images—now we can have our portrait clients order their photos just minutes after they are taken!"

Talented Tips. "If we could share one tip or technique with our industry, we would express the benefits of wedding-day marketing. Barbara has had great success at her weddings with presenting one 4"x5" digital print to the bridal couple and each set of parents at the wedding reception. She simply captures the image during the event and prints it out on the Canon CD 300 digital printer. The image is trimmed and placed in an embossed presentation folder at the beginning of the reception. The result is that the recipients show off the image to everyone in attendance, and we get very positive public relations at the wedding. This is something that *any* studio can do with a very minimal investment in equipment and time."

▶ CURTIS TACKETT

Curtis Tackett has operated his residential studio in Jacksonville, *Florida, since 1991. A Certified Professional Photographer since 1993, his fascination with and love for photography began as a young adult. Over the past twenty-five years he has also worked within the photography field as a lab technician and equipment salesman. He is recognized as a leader in the digital imag-ing field and embraces the use of computers to enhance his work.*

Transition. "As any small business owner knows, it's tough to get started. I started (unknowingly) going digital over eight years ago with the addition of the Fotovix. Back then, it was a bold step. There were only two other studios in the area doing this—and with some resistance from their clients. Given the direct savings (in not using proofs) and the ability to prevent clients from copying my images, it was one of the only ways you could protect yourself.

"Back then there was nobody to talk to about digital imaging. I had to come up with

a way to make some sort of proofs—and at a tremendous savings to my studio. I decided to create digital contact sheets and output them on a 1200dpi laser printer for about 4¢ per page (and four images per page). I also had to come up with new words—I had to call this new book something other than a proof book. I finally came up with "workbook." It truly is a workbook, since the clients write directly on the book—notations about what they would like to have done, cropping directions, opening eyes, relocation of heads and body parts, or removal of items from the scene. It has been an invaluable tool for me to offer this and the total cost of producing 250 or so images is under $7.00 per workbook. We also make the same worksheets for my portrait clients.

"With over 15,000 hours of Photoshop work, I have to say that everything for me now is pretty much routine. I started learning Photoshop over five years ago, thinking that there would be about a one-year learning curve for this program. (Boy, was that ever an underestimate!) I still attend classes in Photoshop every chance I can get, usually once a week. I attend basic, beginning, intermediate, advanced and expert training classes and still learn things in every class that are helpful to me."

Talented Tips. "The transition to digital used to be a very long road, but it has become much shorter. Digital is here. For those who don't agree, figure it is just a fad, or think it isn't as good as film, let me say: *you're wrong*. If you don't make a decision to move in this direction, you may end up like the photographic studios that said that color pictures were just a fad. Where are those photographers today? Being in business, you have to be aware of what is happening in your field and act on that information. Going digital is now more affordable than ever. Cameras selling for $25,000.00 a year ago are now only $6,000.00.

"Education in Photoshop is the most important investment of time you can make. Yes, you will become the lab to a point. Yes, you have to be more involved with your images than simply masking a negative and letting the lab handle the rest. But you will also make more money in the process. Learning how to make money in this arena is more like learning how to charge for things you once took for granted—retouching, black & white, hand tinting, artistic interpretation, etc. I personally know of photographers who charge (and get) over $350 for an 8"x10" inkjet print, framed and signed. That may not be much for some people— but keep in mind that the cost of materials for that sale is only about $2.00 for the print (plus whatever frame you decide to put it in). Learning new ways to make an income keeps us all on our toes. But isn't it better to control your own business than to find out that your competitor or friend down the street offers this product and you can't even talk the language?

"When clients ask what can I do for them, I say that we photograph both in black & white and in color at no additional charge, on every image. We can open your eyes, switch out a bad expression, light a candle that went out during your ceremony—even light *all* the candles if someone forgot to. We can add a flower on the lapel, pick up trash on the floor and fix cracks in the wall. Digital is not the only answer but has been the *total* answer for me.

"Photographic technique is more critical when photographing digitally than with negative film. You must use better judgment in lighting exposure. If you don't use a light meter now, you need to start learning to use

one. The advantage of seeing an image immediately after taking the photograph is a tremendous advantage. You no longer worry, 'Did I expose that image correctly?' or 'Did my flash fire?'

"In over three years of being totally film-free and photographing over 30,000 images, not one image has been lost accidentally. This means you no longer have to worry about carriers or labs losing your film, about film being damaged in transit, or any of the other problems that could occur with film.

"With digital, weddings have taken on a whole new meaning to me. Gone are the days of stressing and sweating and being worried about my camera and film. My clients love the feedback as they see the progression of their event. I no longer worry about how much I have photographed, I just enjoy the experience and go with the flow. My sales are higher and my margins are greater than they have ever been. People ask me do they have to go digital? My response is, no, you don't—that leaves more for those of us who have."

▶ EDDIE TAPP

Since 1973, Eddie Tapp has produced professional photographic assignments ranging from commercial, industrial, portrait and fashion photography to his current foray into digital imaging, consulting, prepress and education. With over eighteen years of experience in computer technology, his digital qualifications have kept him at the cutting edge of the photography industry.

A frequent lecturer at professional workshops and events throughout the country, he is sought out to provide seminars, consulting and training by clients such as Eastman Kodak, Epson, Foveon, Polaroid Corporation, Apple Computer, and a number of government agencies.

Eddie is actively involved as the Chairman of the Committee on Digital and Advanced Imaging for the Professional Photographers of America (PPA) where he holds the Master of Electronic Imaging & Photographic Craftsman degrees and is a Certified Professional Photographer.

His articles have appeared in magazines such as The Professional Photographer, Photo Electronic Imaging, Infoto *and* Southern Exposure. *He has also served on Adobe's Photoshop beta team. To learn more about him, visit his Web site at: www.eddietapp.com.*

Talented Tips. "Making the digital transition requires one simple ingredient: desire—the desire to obtain the quality imaging that you have become accustomed to. If you are in the beginning stages of making this transition, you are going to be faced with a long series of choices for many years to come—operating systems, monitors, software, scanners, storage, archiving, color management, digital cameras, printers, labs and education.

"If I could only give you one bit of advice, it would be to buy a workstation powerful enough to handle the load that you plan to have a year from now. There is no need to start at the top, high-end computer, because you will in all likelihood buy a second powerful workstation within your first two years. Your first workstation will, however, remain very important

in your workflow as a scanning or file management system.

"Selection of equipment will be your most agonizing decision because there is so much to choose from. If you define your business segments for digital imaging, it will become much easier to find the equipment needed to provide the quality you demand. With that in mind, first define what areas of your business you will produce digitally and then get educated in that area. At conventions and group meetings, you'll discover others who have experienced many decisions in the digital world. Ask them for advice as to your needs.

"The ability to control every aspect of your work—from color and tone, to creative aspects and print quality—is very exciting. Digital has brought the craft of being a photographer back into this industry. Prepare to have the most fun you've ever had as a photographer."

CONCLUSION

▶ MAGICAL MEMORIES

Weddings symbolize a beginning, a wish upon a star.
Visions we all hope and pray will take us very far!
When you visualize your future through your looking glass,
Dream of magical possibilities and capture them with class!

As you live your fairy-tale future, write your script in style
and make these memories last for more than just a while.

Whether your dreams include a princess ball, a great adventure
 or a perfect family,
Know that you can digitally capture it all and leave smiling
 with glee!

So as you take your journey to places never been before,
Realize this should not be the closing of our door.

When you hit a stumbling block be sure to shield it with laughter
And know your studio can now live digitally happily ever after!

Best Wishes!
Kathleen & Jeff

DIGITAL PROCESS OVERVIEW

▶ PRE-WEDDING DAY

1. Effective marketing
2. Wedding day worksheet
3. Client status sheet
4. Equipment checklist
5. Assistant training

▶ WEDDING DAY

1. Download images from camera to the laptop and the FireWire drive.
2. During dinner, rotate images and prepare for a slide show.
3. Quick edit to eliminate blinks, bad exposures, etc.
4. Begin slide show.

▶ DAY 1 PRODUCTION

1. Download images to main computer.
2. Prepare backup CD immediately.
3. Copy images into wedding/client folder.
4. Number images.
5. Copy numbered images into work folder (used for video and album design).
6. Burn numbered digital CD to be used for ordering.

▶ DAY 2 PRODUCTION

1. Add artistic flair using image modification.
2. Create videos.
3. Place images on-line.
4. Order vendor stock photos.
5. Send e-mail and leave message to schedule album design.

▶ DAY 3 PRODUCTION

1. Begin process for completed album/other orders.
2. Copy original files into file prep folder.
3. Organize images by final print size.
4. Crop, size and color correct images.
5. Save images as TIF files.
6. Organize orders (create CD, enter in database, ship to lab).
7. After order is placed, verify that CD is accurate and delete images from hard drive.

▶ DAY 4 PRODUCTION

1. Verify numbering on images when they arrive.
2. Cut and organize images.
3. Place miscellaneous orders in gift boxes and call for pickup.
4. Insert mats and images in album.

INDEX

Other Books from
Amherst Media

Wedding Photographer's Handbook

Robert and Sheila Hurth

A complete step-by-step guide to succeeding in the world of wedding photography. Packed with shooting tips, equipment lists, must-get photo lists, business strategies, and much more! $29.95 list, 8½x11, 176p, index, 100 b&w and color photos, diagrams, order no. 1485.

Lighting for People Photography, *2nd Edition*

Stephen Crain

The up-to-date guide to lighting. Includes: set-ups, equipment information, strobe and natural lighting, and much more! Features diagrams, illustrations, and exercises for practicing the techniques discussed in each chapter. $29.95 list, 8½x11, 120p, 80 b&w and color photos, glossary, index, order no. 1296.

Outdoor and Location Portrait Photography
2nd Edition

Jeff Smith

Learn how to work with natural light, select locations, and make clients look their best. Step-by-step discussions and helpful illustrations teach you the techniques you need to shoot outdoor portraits like a pro! $29.95 list, 8½x11, 128p, 60+ full-color photos, index, order no. 1632.

Wedding Photography:
CREATIVE TECHNIQUES FOR LIGHTING AND POSING, *2nd Edition*

Rick Ferro

Creative techniques for lighting and posing wedding portraits that will set your work apart from the competition. Covers every phase of wedding photography. $29.95 list, 8½x11, 128p, full-color photos, index, order no. 1649.

Professional Secrets for Photographing Children
2nd Edition

Douglas Allen Box

Covers every aspect of photographing children on location and in the studio. Prepare children and parents for the shoot, select the right clothes capture a child's personality, and shoot storybook themes. $29.95 list, 8½x11, 128p, 80 full-color photos, index, order no. 1635

Photographer's Guide to Polaroid Transfer
2nd Edition

Christopher Grey

Step-by-step instructions make it easy to master Polaroid transfer and emulsion lift-off techniques and add new dimensions to your photographic imaging. Fully illustrated every step of the way to ensure good results the very first time! $29.95 list, 8½x11, 128p, 50 full-color photos, order no. 1653.

Creative Techniques for Nude Photography

Christopher Grey

Create dramatic fine art portraits of the human figure in black & white. Features studio techniques for posing, lighting, working with models, creative props and backdrops. Also includes ideas for shooting outdoors. $29.95 list, 8½x11, 128p, 60 incredible b&w photos, order no. 1655.

Wedding Photojournalism

Andy Marcus

Learn the art of creating dramatic unposed wedding portraits. Working through the wedding from start to finish you'll learn where to be, what to look for and how to capture it on film. A hot technique for contemporary wedding albums! $29.95 list, 8½x11, 128p, b&w, over 50 photos, order no. 1656.

Studio Portrait Photography of Children and Babies
2nd Edition

Marilyn Sholin

Learn to work with the youngest clients to create images that will be treasured for years. Includes tips for working with kids at every developmental stage, from infant to preschooler. Features: lighting, posing and much more! $29.95 list, 8½x11, 128p, 90 full-color photos, order no. 1657.

Professional Secrets of Wedding Photography

Douglas Allen Box

Over fifty top-quality portraits are individually analyzed to teach you the art of professional wedding portraiture. Lighting diagrams, posing information and technical specs are included for every image. $29.95 list, 8½x11, 128p, order no. 1658.

Storytelling Wedding Photography

Barbara Box

Barbara and her husband shoot as a team at weddings. Here, she shows you how to create outstanding candids (which are her specialty), and combine them with formal portraits (her husband's specialty) to create a unique wedding album. $29.95 list, 8½x11, 128p, 60 b&w photos, order no. 1667.

Fine Art Children's Photography

Doris Carol Doyle and Ian Doyle

Learn to create fine art portraits of children in black & white. Included is information on: posing, lighting for studio portraits, shooting on location, clothing selection, working with kids and parents, and much more! $29.95 list, 8½x11, 128p, 60 photos, order no. 1668.

Infrared Wedding Photography

Patrick Rice, Barbara Rice & Travis HIll

Step-by-step techniques for adding the dreamy look of black & white infrared to your wedding portraiture. Capture the fantasy of the wedding with unique ethereal portraits your clients will love! $29.95 list, 8½x11, 128p, 60 images, order no. 1681.

Corrective Lighting and Posing Techniques for Portrait Photographers

Jeff Smith

Learn to make every client look his or her best by using lighting and posing to conceal real or imagined flaws—from baldness, to acne, to figure flaws. $29.95 list, 8½x11, 120p, full color, 150 photos, order no. 1711.

Innovative Techniques for Wedding Photography

David Neil Arndt

Spice up your wedding photography (and attract new clients) with dozens of creative techniques from top-notch professional wedding photographers! $29.95 list, 8½x11, 120p, 60 photos, order no. 1684.

Basic Digital Photography

Ron Eggers

Step-by-step text and clear explanations teach you how to select and use all types of digital cameras. Learn all the basics with no-nonsense, easy to follow text designed to bring even true novices up to speed quickly and easily. $17.95 list, 8½x11, 80p, 40 b&w photos, order no. 1701.

Professional Secrets of Natural Light Portrait Photography

Douglas Allen Box

Learn to utilize natural light to create inexpensive and hassle-free portraiture. Beautifully illustrated with detailed instructions on equipment, setting selection and posing. $29.95 list, 8½x11, 128p, 80 full-color photos, order no. 1706.

Portrait Photographer's Handbook

Bill Hurter

Bill Hurter has compiled a step-by-step guide to portraiture that easily leads the reader through all phases of portrait photography. This book will be an asset to experienced photographers and beginners alike. $29.95 list, 8½x11, 128p, full color, 60 photos, order no. 1708.

Traditional Photographic Effects with Adobe Photoshop

Michelle Perkins and Paul Grant

Use Photoshop to enhance your photos with handcoloring, vignettes, soft focus and much more. Every technique contains step-by-step instructions for easy learning. $29.95 list, 8½x11, 128p, 150 photos, order no. 1721.

Master Posing Guide for Portrait Photographers

J. D. Wacker

Learn the techniques you need to pose single portrait subjects, couples and groups for studio or location portraits. Includes techniques for photographing weddings, teams, children, special events and much more. $29.95 list, 8½x11, 128p, 80 photos, order no. 1722.

Photographic Lenses
PHOTOGRAPHER'S GUIDE TO CHARACTERISTICS, QUALITY, USE AND DESIGN

Ernst Wildi

Gain a complete understanding of the lenses through which all photographs are made—both on film and in digital photography. $29.95 list, 8½x11, 128p, 70 photos, order no. 1723.